MW00818054

THE CEDAR KEYS
HURRICANE OF 1896

THE CEDAR KEYS HURRICANE OF 1896

DISASTER AT DAWN

ALVIN F. OICKLE

THE
History
PRESS

Published by The History Press
Charleston, SC 29403
www.historypress.net

First published 2009

ISBN 9781540219558

Library of Congress Cataloging-in-Publication Data

Oickle, Alvin F.
The Cedar Keys hurricane of 1896 : disaster at dawn / Alvin F. Oickle.
p. cm.
Includes bibliographical references.
ISBN 9781540219558
1. Cedar Key (Fla.)--History. 2. Hurricanes--Florida--Cedar Key. I. Title.
F319.C43O37 2009
975.9'7061--dc22
2009007036

CONTENTS

ACKNOWLEDGEMENTS

T he subjects of this story are the Cedar Keys and Hurricane Number 4 in 1896. I felt uncomfortable when I began a storm education, but from the beginning I was encouraged to jump into a science quite unfamiliar to me. An early volunteer adviser was Donald C. Gaby, a fellow Floridian and former U.S. Air Force weather officer (meteorologist) who was in charge of environmental satellite operations at the National Hurricane Center in Miami for thirteen years. He was helpful with suggestions on sources, and he read the manuscript in draft form. My first exploratory visit to the Internet took me to Stormpulse.com. This is a remarkable archive of hurricane history compiled by Matthew Wensing and Brad Wiemerslage.

Dr. Christopher W. Landsea, science and operations officer at the National Oceanographic and Atmospheric Administration/National Weather Service/National Hurricane Center, Miami, like Matt Wensing, went the extra mile in answering my questions and reviewing draft reportage promptly and cheerfully. Help came also from Gloria Aversano, librarian at the NOAA Miami Regional Library. Technical information was also provided by author Jay Barnes, director of the North Carolina Aquarium at Pine Knoll Shores, Atlantic Beach; Charles H. Houder, deputy executive director of the Suwannee River Water Management District, Live Oak, Florida; and Dr. Francis E. Putz, Department of Botany, University of Florida.

Major sources of information and encouragement in gathering Cedar Keys history were offered by a man some think of as "Mr. History," Lindon J. Lindsey of Chiefland, Florida. He has chaired the Levy County Archives Committee since 1984 and was a major contributor in writing articles and compiling information for the series of twenty-eight booklets under the title *Search for Yesterday*. This mine of information includes such county records as marriages, tax lists, census information, family genealogy and, most notably, scores of newspaper columns written by Sidney Gunnell for the newspaper *Chiefland Citizen*. I owe Lindon Lindsey, the *Search* series and all who helped in its publication a large thank-you.

ACKNOWLEDGEMENTS

At Cedar Key itself, I had the same spirit of encouragement from Dr. John Andrews. His family has a long association with this special place, and he has been a major benefactor and officer in the Cedar Keys Historical Society. Also assisting with information were the staff at the Cedar Key Public Library and city clerk's office; Jill Pinion, at the *Cedar Key Beacon* office; Gene Benedict, former *Beacon* columnist; and Eric Brogren, Molly Cowart, Wilma Holman, Winnelle Horne and Marie Johnson. Michael Miller got me safely to, and back from, Atsena Otie.

Mary Lou Michler at the Ormond Beach Public Library was aggressive in collecting microfilm for my newspaper study. Colleen Seale at the University of Florida Library West Reference Desk was especially helpful in checking sources. Reference desk staffers were helpful also at the John F. Germany Library in Tampa and at Atlanta's Main Library. At the State Archives of Florida, I was impressed with the assistance given by N. Adam Watson, photographic archivist.

I am grateful also for the patience and assistance that came from staff at The History Press. My editor, Laura All, found answers to my frequent questions and shepherded the many elements combined to make this book. Helpful also were Jaime Muehl, copyeditor, and Marshall Hudson, THP's talented art director.

INTRODUCTION

There is probably no feature of nature more interesting to study than a hurricane.
—*F.H. Bigelow, 1898* Yearbook of the U.S. Department of Agriculture[1]

F ollowing the path of a roving storm reaffirms a constant in all our lives: we are never the first to suffer, nor are we the last. The winds and rains of an Atlantic hurricane, while gathering speed and force, appear determined and relentless. After landfall, the raging force downgrades slowly, seemingly with reluctance. The ravaging elements slash a trail over damaged miles before returning, finally, to the condition of their legendary birth—under the gentle flap of an African butterfly's wing. Behind, in the scar the storm has sliced, battered humans quiver yet, with returning strength, overcome the struggles to continue existing in a part of the world that has changed but is still worth inhabiting.

We can say that about most Atlantic hurricanes that make landfall. What we say about a specific storm often is determined by the location of landfall and the first major damage it causes. This story is about a hurricane that crashed ashore in 1896 over a small cluster of islands in the Gulf of Mexico. Called the Cedar Keys,[2] this group has many different patches of sand and stone—even mud—some with marsh grass. The islands poke up from the Gulf's warm and shallow ocean water and lie just below the armpit formed where the peninsula and panhandle meet, about twenty miles from the mouth of the Suwannee River.[3]

For this story, the focus falls on the islands called Atsena Otie (formerly Depot Key) and Cedar Key (formerly Way Key), as well as on the people, their industries and their lives. The story, like the hurricane that came to be called Number 4–1896, spreads to states all the way into New York. Not unlike others of these monster storms, Number 4 took on two different "personas." The first was exhibited in these Gulf of Mexico islands. The horrible damage there was caused primarily by a surge of ocean water. This wave, eight to ten feet high, swamped most of the low-lying islands. The term *tidal wave* was

INTRODUCTION

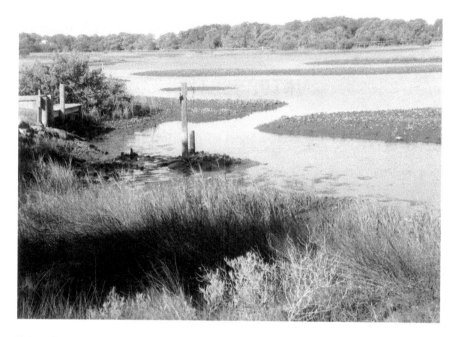

Depending on what one calls an "island," the Cedar Keys region southeast of the Suwannee River in the Gulf of Mexico has anywhere from thirty at high tide to hundreds at low tide. *Author's photo.*

incorrectly applied. Nor would it be accurate to use a word now related to Pacific and Indian Ocean storms; *tsunami* is intended to define the cause as an earthquake. The second persona of Number 4 came with the winds. They caused damage that was major in a few places and virtually nonexistent in others. Professor Bigelow's description of a hurricane notes that the eye of a hurricane, perhaps twenty miles in diameter, brings a sudden pause. After what has been called "twenty minutes of grace,"[4] Number 4, with incredible speed, zipped from the Gulf of Mexico into Canada in a mere twenty-four hours. No other area, however, suffered loss of life and property as did the Cedar Keys and the coastal mainland northwesterly to the Suwannee River. And yet, in an ironic and pleasant way, the disaster that befell the Cedar Keys helped it become a place apart from the mainland, both geographically and metaphysically.

In my research, I have been pleased to find many sources. A few of the newspapers of the time seemed, in some issues, to be so dedicated to getting the story that they published hearsay, gossip and rumor. It is my practice to seek confirmation from multiple sources. Some of the spellings have been corrected for the purpose of clarity, as have such stylistic forms as

punctuation and capitalization. This has been done only to help clarify an occasionally obscure account.

I have attempted to overcome my own distaste for using in quoted material words like "colored" by recording them only when their absence could be seen as distorting the meaning. For example, newspaper accounts of the hurricane typically identified casualties by name and race. In the appendix, that information is included for the possible benefit of those seeking genealogical information.

More subtle in 1896 was white society's generally low regard for nonwhite people. In one account used in this story, we are informed that "there was no one hurt or lost except one colored man." Because the man was black, the white narrator found "no one hurt or lost except…"

Florida is perhaps not unlike any other pioneer state in having uncounted communities that are no more. Some of the difficulty of doing this research was compounded by trying to trace places that had vanished or at least changed names. I refer in the story several times to Lindon J. Lindsey, a Levy County historian who lives in Chiefland, one of the county's larger settlements. He was born in 1926 in Cedar Key. His father, Lindon H. Lindsey, lived as a boy in a place near the Suwannee River called Fish Bone. The neighborhood, for that is all it ever was, also comes up in this story as residents helped lost travelers return to their homes. There is no Fish Bone today. There have been many name changes; for example, Phoenix became Montbrook and remained in Levy County, but Joppa in Alachua County was later to become Trenton in Gilchrist County. Columnist Sidney Gunnell once listed one hundred Levy County place names that had disappeared. On the list were such neighborhoods as Margaret Blanton's House, Wekiva Hammock, Mud Slue and McGee's Branch.[5]

Most important to the reader is knowing that Cedar Keys, the large group of small islands, and Cedar Key, the tiny city on one island, are still here. The islands have gone through changes in the century since the 1896 storm. Lopsided legends have developed, and actual events have been enlarged by exaggeration into compelling but fictional stories. A 1945 St. Petersburg writer used imaginative phrases in what he claimed was "the story of Cedar Key," among them: "in half an hour it was all over"; "the big concrete building…crashed to the ground as if struck by an atomic bomb"; and "the glory that was Cedar Key was merely a paragraph in the history book." Even today, reference is made to "a rather nasty hurricane [that] all but erased the town."[6] But "all but" doesn't count. Although a different population is being served, Cedar Key is alive and well.

CHAPTER 1

AUTUMN IN THE CEDAR KEYS

On the Feast of St. Michael, a day to most of us calm and bright, crisp and delicious, with the breath of early autumn, the storm-god seemed to be let loose along our coast.
—C.K. Nelson, bishop of Georgia[7]

When the calendar recorded the arrival of autumn in 1896, the weather stations in the eastern United States were only moderately busy with what often occupied them at that time of year. The hurricane season had already brought two alerts. The first storm, in July, had smashed through the Florida Panhandle. High winds at landfall, estimated at one hundred miles per hour east of Pensacola, had fallen to forty by the time the storm passed east of Atlanta, Georgia. The second storm had stayed well out in the Atlantic Ocean before decaying.[8]

Two more storms were forming in the Caribbean Sea on September 21 as Atlanta's local forecast official, J.B. Marbury, logged Fahrenheit temperatures in the sixties and seventies for the Atlantic and Gulf States.[9] Number 3 was plotted that evening nearly five hundred miles from Miami and, twenty-four hours later, nearly four hundred miles off the coast of Charleston, South Carolina. With winds of one hundred miles per hour and moving at a land speed of thirteen miles per hour, this storm required watching. If its track continued northwesterly, Number 3 could make landfall at North Carolina and Virginia, possibly even striking Washington, D.C.

The Number 4 storm, gathering forces south of Puerto Rico, had winds around forty miles per hour and did not seem in a hurry to move westward in the Caribbean. For weather observers, Number 4 was a tropical depression and, at this rate, was not likely to bother anybody for a few days, if at all. Marbury saw this as "a typical West Indies storm, common at this season of the year."[10] Busy in his Georgia office, Marbury was not to take notice of this disturbance until the morning of September 28. By then, Number 3 had veered sharply east and north and was spinning to its end in the mid-Atlantic. Number 4, however, had passed the Caribbean islands and was

entering the Gulf of Mexico, turning away from a path that would have taken storm conditions to the Mexican island of Cozumel. "At 8 o'clock a.m. September 28th," Marbury wrote,

> *the winds were blowing spirally inward from right to left toward the center of disturbance, a peculiarity of all such storms* [and] *the center of the storm was probably several hundred miles from the* [southwest Florida] *coast. It moved slowly northward during the day.*

In his comprehensive work, *Florida's Hurricane History,* Jay Barnes wrote:

> *By 1896, the Weather Bureau had established a network of almost fifty meteorological reporting stations across Florida. The bureau itself had stations in Pensacola, Jacksonville, Tampa, Jupiter, and Key West. More than forty other voluntary meteorological stations and numerous "forecast display stations" completed the network...Telegraph lines out of Florida routinely carried the news of approaching hurricanes to ports along the coast in the mid-Atlantic and northeastern states. Unfortunately, the network was not as beneficial to the coastal residents of Florida, who rarely enjoyed the advantage of forewarning.*

Another factor has been noted by Dr. Christopher W. Landsea, science and operations officer of the National Oceanographic and Atmospheric Administration. He explained, in an e-mail to me:

> *Also, while in 1896 communication between the U.S. and the Caribbean islands were quite good because of telegraph lines, the same was not the case for hurricanes headed toward the U.S. from the Atlantic Ocean. Ships out at sea did not have access to two-way radio (until 1906), so hurricanes over the open ocean that ended up striking the Atlantic seaboard were usually not well anticipated back then.*

In other words, a big storm—a hurricane!—could just as easily roar off the ocean and slam into land. As things would develop with the Number 4 storm that September, forecasting science and all the necessary communication tools were to be of no help in preparing people anywhere in Florida for what was to come.

Florida, of course, had often seemed like the targeted bull's-eye for surprise West Indies storms. Science had not yet brought the tools and knowledge to

14

the recognition of weather conditions and the certainty of science that were to come in the decades ahead. The art and science of finding and following storm systems was still being developed. Observers had not tracked the first hurricane on a map until 1875.[11]

A warning of sorts had been given about Hurricane 4 along Florida's east coast. On the west coast, most Floridians were going about their business on autumn's first day in 1896. Fall was harvest time for cotton, citrus fruits and vegetables. Other kinds of agricultural and marine work were being carried on in the region where the panhandle leaves the peninsula and stretches west over the Gulf of Mexico. Men in the many small counties between Jacksonville and Tampa had year-round work cutting timber, producing turpentine, gathering sponges and fishing. Especially busy were the hardy people who lived on the islands called the Cedar Keys.

The Cedar Keys are far north of the better-known chain of connected islands dangling from the state's southern tip. That group, which runs south

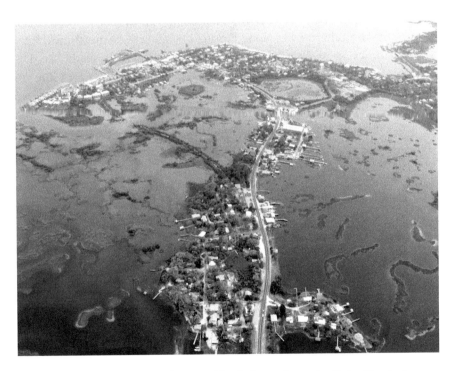

This aerial view shows a few of the many islands that make up the Cedar Keys in the Gulf of Mexico. The curving embankment at the left once carried railroad trains onto a wood dock. Filled with shells and other material, the wharves became Dock Street. *Photo © Bill Kilborn.*

and west to end at Key West, is called the Keys and is formally named the Straits of Florida. The Cedar Keys consist of many small, unconnected islands. The inhabited islands reach three miles into the Gulf, well west of Ocala and southwest of Gainesville. Because of the circumstance of location and nature's rich products in the nineteenth century, the biggest island, called Way Key until the name was later changed to Cedar Key, had one of the few eastern ports open for both railroad and steamboat freight and passenger service.

To some, the Florida Railroad Company was known as the Cedar Keys Railroad because that is where the line terminated on the state's west coast. Trains ran between the islands and Fernandina on the Atlantic coast near the Georgia state line, saving days of ocean travel around the peninsula. The trains stopped in Baldwin and Gainesville to deliver and pick up goods. Tons of products from the islands and the coastal mainland were loaded onto freight cars. Steamships loaded with lumber, shellfish and passengers bound for Europe, Cuba, New York, Texas and other ports around the Gulf of Mexico also departed from Cedar Keys docks. The trains enabled passengers to get to other southern cities along Florida's Atlantic coast, northward into Georgia and as far as New York. From Baldwin, passengers could transfer for trains to Savannah and Jacksonville. Cedar Key was a very well-known transportation center in the last quarter of the nineteenth century.

The phrase would not have been used in nineteenth-century America, but Cedar Keys was at that time a "destination" for vacationing and recuperating people from around the country. No chamber of commerce could have written a more inviting description of the Cedar Keys in 1871 than the author of a story, "Along the Florida Reef," published in *Harper's New Monthly Magazine*. The anonymous traveler wrote:

> *Along the whole south shore from Charlotte's Inlet to Cedar Keys, where we now come to anchor, a fine white silicious sand is the prevailing component of the soil. Seahorse Key…is of the same character. As the substructure is of coral formation, this sand must have been carried from the great outlets of the upper trend of the Gulf coast…The [Cedar Key] harbor is very shoal, but narrow winding channels lead to the town on Way Key, where the railroad from Fernandina terminates.*

The Cedar Keys, with a final *s*, are generally considered to be all the Gulf of Mexico islands within Levy County, according to Lindon J. Lindsey, who has chaired the county's archives committee for the past quarter of a century. That area, which abounds in Native American names, ranges from

Autumn in the Cedar Keys

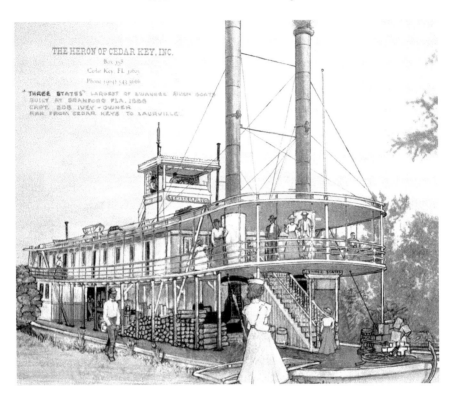

The *Three States*, built at Branford, Florida, in 1888, was the largest of the Suwannee River steamboats. Captain Bob Ivey's paddle wheel boat cruised the Cedar Key–Luraville route. *Photonegative of an etching by Alfred H. Robson. State Archives of Florida.*

the Suwannee River southeasterly along the coast to include Waccasassa Bay and Withlacoochee Bay, ending at the Withlacoochee River. This gives Levy County 58 miles of coastline—more than three times New Hampshire's 18 coastal miles. In addition, Levy County has 101 lakes and 106 miles of rivers.

As for the islands' English names, they are mostly descriptive. A few can be confusing because of changes made in the nineteenth century. Today, the city of Cedar Key is centered on what was formerly called Way Key. Author-historian Charles C. Fishburne Jr. explained that by 1879 the town was being referred to as Cedar Key, no longer Cedar Keys. He wrote: "Confusion persisted as the U.S. Post Office retained the designation 'Cedar Keys' into the next century, corresponding to the concept of the Port of Cedar Keys, embracing the channels, harbor, several islands, etc."

John Muir would not have been welcomed by any community seeking what it called "progress" by boasting of its hearty but unprotected resources on land

17

and in the sea. In 1867, when Muir arrived in Cedar Key to stay a few months, he had completed a "thousand-mile walk to the Gulf" from his Indiana home. The twenty-eight-year-old naturalist was forming a philosophy that would guide him in seeking ways to preserve America's rich forests and rolling valleys. Walking from Fernandina to Cedar Keys, Muir had marveled at the "watery and vine-tied" land and the "still young" streams. In his journal, he mentioned "broken fields, mills, and woods ruthlessly slaughtered."[12]

Muir was one of the first to decry the condition of Cedar Key–area woodlands, remarking on the woodlands' "slaughter." He surely must have wondered why local landowners were not arranging for new growth as a means of continued harvesting. The decline in resources was to continue. Another observer of wasteful practices, Fishburne cited especially the extravagant waste in one of his well-documented books on regional history, *Cedar Key Booming: 1877–1886*. Fishburne set the 1885 Florida state census population figure of 1,887 as the city's largest recorded head count in the nineteenth century, despite journalists and authors claiming figures as high as 5,000. "All reliable evidence suggests that population decline commenced soon after 1886," he wrote.

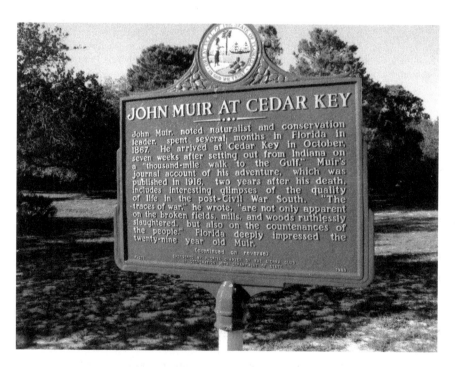

A historic marker tells of naturalist John Muir's nineteenth-century visit. *Author's photo.*

Fishburne credited the first use of the name Cedar Key to Augustus Steele in 1843. Steele, a Levy County judge and state representative, renamed the island that the United States Army had called Depot Key. In 1852, Steele changed it again, this time to Atsena Otie, the Creek words for "cedar island." Seven years later, Steele incorporated the city of Atsena Otie. Also in 1859, a Florida Railroad Company surveyor plotted the Way Key streets, and in 1878 the municipal council on Way Key voted to call the community "the Town of Cedar Key," thus using the name Steele had earlier given the island newly named Atsena Otie. Now there were two municipalities, Atsena Otie and Cedar Key, separated by a half mile of Gulf of Mexico ocean water. Ferry service over the years helped keep the separate settlements united.

In the summer days of 1896, Captain Bob McCleary headed a four-man fishing crew. They left Cedar Key on August 15, hoping to take tons of fish by net and to sell them at the fish houses on Cedar Key docks. They completed at least one run and split the proceeds they received—a third for McCleary, the rest divided among the three crew members. In the early days of autumn, they were near the mouth of the Suwannee River, not far north of the Cedar Keys. The "boy" on this trip was fourteen-year-old William Delaino.[13] By September 28, McCleary's crew, which included Tom Wallace and Vernon Wilson, had netted another nine hundred pounds of mullet. The fish were on ice, which they had loaded into one of their two small run boats, the *Matty F.* The preservative most likely had come from W.S. Ware's Ice Factory on Cedar Key.

Another young man, nineteen-year-old Will Yearty, was camping at Geiger Creek with his father, Bill Yearty, and Will's friend, Tom Howard.[14] They had settled into a comfortable camp among large oak and pine trees on the south side of the Suwannee River.

Velma Crevasse, a ten-year-old, was with her family at their three-story home on Atsena Otie. This island is almost completely flat, and so a ten- or fifteen-foot rise would seem like a hill. The small population, proud of their community, had erected a combined church/school/Masonic Lodge quarters building in 1875. Velma no doubt had chores as part of her mother's home training, including helping care for the baby, the youngest of the three Crevasse children. Captain Crevasse, Velma's father, regularly ran his schooner to Key West.[15] The Crevasse family lived near a neighbor's "house on a hill."

Like Velma, three-year-old Katherine McCumber was living with her parents in one of the lower-lying areas of the more settled island, Cedar Key.[16] The McCumbers also had a neighbor whose land was higher. The height of a "hill" in any of the Cedar Keys is measured in feet, not yards. The highest point on all the islands, according to several sources, is on

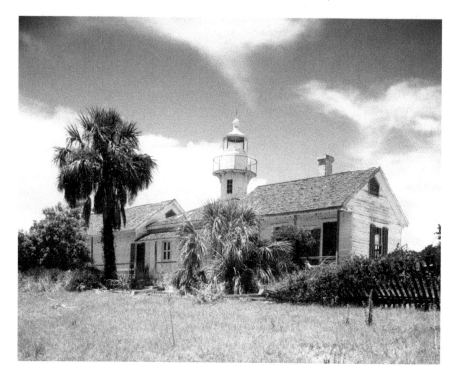

The lighthouse on Seahorse Key is now a University of Florida laboratory. *State Archives of Florida.*

Seahorse Key. On this island of 109 acres, a lighthouse was erected in 1854 atop a rise fifty-two feet above the water. That is still considered the highest natural point in the Cedar Keys.

For Leonard S. Tawes and Nicodemus Wilder, both veterans of years on the water, September was just another month of summer. Tawes[17] was captain of a three-masted schooner, the *City of Baltimore*, which carried freight along the Atlantic coast and to South America. In his last run with a load of lumber to Curaçao, a Dutch island near Venezuela, he had missed by only a few days being in the West Indies on September 21 when a tropical disturbance was first noticed. That was Number 4 at its birth. Next on Captain Tawes's busy 1896 schedule was another Curaçao run. When he arrived at Fernandina, Florida, on September 24, he checked in at the United States Customs office and arranged for a towboat to pull his ship some thirty miles over a seven-hour period up the St. Mary's River. That tidal river forms the Atlantic coast boundary between Florida and Georgia. Tawes docked his freighter at Kings Ferry on the Florida side, where his cargo was to be loaded from the sawmill business he called Messrs. Mozelle & Brother.

Autumn in the Cedar Keys

Wilder, like most men of the times a jack-of-all-trades, had recently finished construction of two cypress boats, a skill for which he was admired at Lake City and throughout the area around the Suwannee River.[18] As L.L. Barnett told the story in 1979, Nick Wilder agreed to rent the new boats, fishing nets and food supplies to Jim Reeves, a friend and, in those days, a neighbor, although he lived five miles away. The transaction took place without a down payment or security deposit. Jim's farm crop had failed that fall and he didn't have "a dollar," according to Nick. An earlier trip with Nick had brought Jim a good profit from the sale of fish, and now he wanted to return to the Cedar Keys as a way of earning enough to tide him over during the coming winter.

Nick's wife, Sara, insisted that Nick should travel with Jim: "I rather you would go with him than to let him take that stuff off way down there." She wanted Nick to protect his property. When Nick demurred, Sara said, "I know that you hadn't planned to go this time, but you just made those two boats for looks, huh?" Not completely with reluctance, Nick agreed to follow Sara's advice. Not until Reeves showed up at the Wilder place on the morning of September 28, ready for his trip, did he learn that Wilder was to accompany him. With help, the men and their equipment were drawn by a team of horses to the banks of the Suwannee River. After leaving their launching site, Nick reported:

> *We drifted on down* [in] *as beautiful conditions as I ever remember. The skies were the most unusual that I had noticed. They were as fair as I have seen...The sun was shining most of the time, but it seemed to shine like there was a heavy fog in front of it, and there was a terrible heat.*

The Cedar Keys were in 1896, and are now, a group of snuggled islands connected by bridges and causeways. The city of Cedar Key is surrounded by many smaller islands, as many as forty of them having names. Cedar Key's downtown grew on Second Street, a few hundred yards from the main dock running parallel with Front Street (now known as First Street). From the central wharf were the extended arms of other wooden docks, generally in the configuration familiar to modern marinas. The main dock was the center of a major transportation system, not only for the islands but also for much of Florida's west coast. Steamboats ran up the harbor channel to the wharves, and railroad trains pulled onto the main dock. The steamers were connecting Cedar Key to New Orleans, Key West and Havana. The railroad line was one of the first in United States history. David Levy Yulee, who was Florida's first United States senator, ran a line

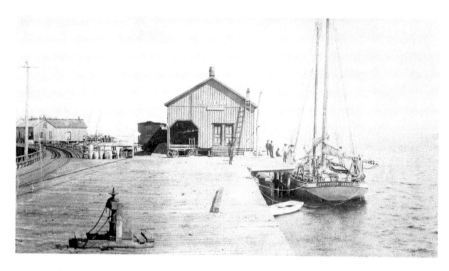

Railroad freight cars ran onto the Cedar Key wharf. *State Archives of Florida.*

155.5 miles across the north of the Florida peninsula. Completed in 1861, the Florida Railroad Company[19] connected east and west coast deep-water ports and some of the nation's major cities. Kevin McCarthy's *Cedar Key, Florida: A History* reports that the Florida Railroad contracted with the United States Postal Service to carry mail three times a week between New York and New Orleans—by way of Cedar Key. Yulee is also credited with establishing services between Cedar Key and Havana and between Fernandina and Charleston, South Carolina.

The westbound railroad tracks ran straight over trestles anchored on tiny islands beginning in the east with the point known locally as "No. 4," going out three miles from the mainland. The tracks finally curved neatly, almost elegantly, into the east end of Cedar Key's business district, ran past the railroad depot and stopped on the docks. The United States Customs office, a couple blocks behind Front Street, was a busy place with Caribbean traffic alone. At one time, Cedar Key and Key West had Florida's only customs offices.

The downtown business district had several popular places for visitors' accommodations, notably the Schlemmer House and the Bettelini Hotel. A *Daily Florida Citizen* correspondent who visited Cedar Key that early October was to report, "Both hotels were very substantially built of coquina [stone]." No less strong was the ten-room Island Hotel, constructed in 1859 with twelve-inch oak beams and cypress boards on a foundation of oyster shells and lime rock.

One of the many logging camps that sent timber to Cedar Key sawmills. *State Archives of Florida.*

Throughout the business area were one- and two-story buildings. Sawdust and pine sap must have littered the floor of the Bar Room when loggers came to town for their breaks. Woodsmen and sailors also would have spent free time with "T.W. Davis, wines, liquors, cigars, and billiards." Here also were the stores and warehouses of Cottrell & Finelson and C.B. Rogers Company; McCullom's Drug Store across from the Schlemmer House; and the city hall. In nearby streets were the buildings that make a town a town: churches, the Odd Fellows Hall, the two-story public school and scores of homes. Many of the houses occupied by tenants who worked in sawmills and in logging were owned by the Town Improvement Company. The company holdings included Hodgson Hill, acquired in 1891 from Sarah Hodgson. At thirty-seven feet above mean sea level, this land was the highest on Cedar Key and surely the most likely to feel the full force of a hurricane. Historian Fishburne speculated that the Hodgson home may have been gone before 1896.[20]

Besides the special cedar cut for pencil manufacturing, the islands and nearby mainland wood stands were swarming with crews cutting other wood species for lumber and for making turpentine. Levy County's quarter of a million acres were rich in timber. The Fennimore Mill made planks, posts and other piece of lumber from pine, oak and other trees then still abundant.

The Eagle Pencil Company office building on Third Street had distinctive architecture. The sawmill buildings behind the office ran to the water's edge. *State Archives of Florida.*

Wolf, Darby and Suskind were among other mills filling the outbound rail cars. Turpentine was another major product harvested from area trees. Like northern maple syrup producers, turpentine crews punctured pine trees to catch sap. Florida alone in that period produced more than fifteen million gallons of turpentine and a million gallons of resin annually.[21]

The Eagle Pencil Company plant was at the edge of the water, at Third and F Streets, almost across the harbor from the huge Eberhard Faber Company sawmill on Atsena Otie. Eagle, years before, had an eighty-two-foot, seventy-eight-ton gross weight merchant vessel built at a Cedar Key shipyard. It was, of course, called the SS *Eagle Pencil.* Gene Coon's shipyards on Piney Point had built boats for spongers for more than twenty years.[22] Some of the town's men who did not work on the water had jobs in these places or at several mainland sawmills that contracted work for the Faber and Eagle companies. The Eagle factory in Cedar Key made pencils, importing the clay and other products to make the finished product. Like its rival Faber, Eagle had its roots in Germany. From Furth, a Bavarian city, the partners—Berolzheimer, Ilfelder and Reckendorfer—had decided to make pencils in America under the simpler name "Eagle." The first plant was in New York, but when new

sources of wood were needed, the company decided to open near one of the country's best cedar stands and founded the Cedar Key factory.[23]

The wood from cedar trees was prized as "a pencil wood that would not warp or splinter" and was, therefore, "far superior to other woods," author Henry Petroski explained in his book *The Pencil: A History of Design and Circumstance.* In a sense, the "circumstance" of the pencil's manufacturing began in Levy County, Florida, which embraces the Cedar Keys, and at a few similar stands in Georgia and Tennessee. That's where the aromatic red cedar grew in abundance. The downside of using cedar was that the tree grows so slowly. Petroski noted that "the average 200–400 year-old tree yields hardly enough wood to make 200,000 pencils. [But] only one-fifth of a typical tree might be suitable for use." Annual pencil production throughout the world was in the hundreds of millions, making it easy to understand how quickly a few thousand acres of cedar could be laid bare.

Faber shipped slats of red cedar for processing into pencils from Atsena Otie to its factory in New York and also to the home plant in Stein, Germany. John Eberhard Faber, as early as in his thirties, was considered "the New York pencil baron." After 1851, he had acquired "large tracts of forest land on Cedar Key from which he would be able to ship cedar-wood slats ready to be made into pencils." Petroski added, "Indeed, securing cedar tracts may, in fact, have been the principal purpose in Eberhard Faber's coming to America, for the wood was by far the best in the world for making pencils." A relative, A.W. Faber, had had an agent in New York since 1843. But Eberhard (dropping his first name, John), built his first factory beside Manhattan's East River at the site of today's United Nations complex. When fire destroyed the building in 1872, Faber moved to Brooklyn. It was to that factory that Cedar Key slats were shipped in 1896. After Faber's death in 1879, his sons, Lothar and Eberhard II, assumed control of the business.[24]

"THIS WAS A STORM"

No man can know the good feeling, until he has this need of getting onto dry land again.
—Nick Wilder

A Monday workday in Levy County was not much different in the autumn than in the summer. Robust young men felled and trimmed trees, or farmed turpentine, and spent the evening in their logging camps, perhaps walking into Bronson and other large mainland communities, if they were near, for supplies and entertainment. History columnist Sidney Gunnell was writing about turpentine workers, but his description fits all those employed in the forests:

> *In the remote locations, the operator had to act as doctor, lawyer, sheriff, and judge. The work was hard, the summer heat was sweltering, the flies and mosquitoes swarmed, and all of that sounds terrible. But the turpentine people had a basic, raw vitality, a brawling lusty love of the life that seems to be disappearing. There were very few fat turpentine workers. Nervous breakdowns were extremely rare among them.*[25]

William S. Yearty, who was born in 1877, wrote in a reminiscence published in a volume of *Search for Yesterday* that

> *the woods were full of deer, turkey, and wild hogs, so that they [loggers] had their food free, and they could haul their cast nets to the creeks and catch fish. Those people sure did eat well: hot biscuits, hush puppies, cabbage palmetto, venison, and in winter time oysters.*

Grits were doubtless on the menu also.

Fishing was a major activity. These were not hard times, but everyone knew how to "make do." Nets were the best way to bring the most fish into a boat, and the Sears, Roebuck & Co. catalogue had nearly two pages of nets

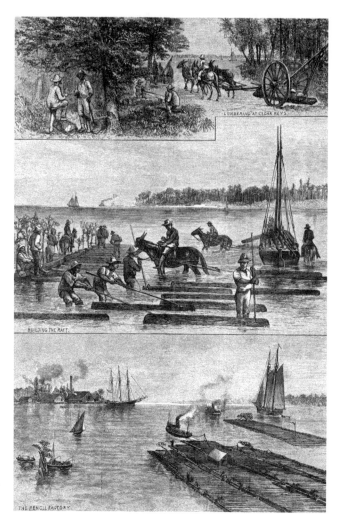

Red cedar lumbering is depicted in three 1882 drawings by a *Harper's Weekly* artist. *State Archives of Florida.*

to sell, not to mention a "stiff high-bust corset" for $0.90 and "men's river shoes" for $3.75 (2009, $37.00 and $157.00, respectively). The catalogue also listed "Our Success Sewing Machine" for $8.50 (2009, $357.00) and "Nottingham Lace Curtains, fifty inches wide, 3½ yards long," at $1.50 a pair (2009, $63.00). Cedar Keys' homemakers, undoubtedly women only, were at home with the children, making meals, beds and every effort to keep the menfolk comfortable.

Hundreds of families subsisted on the men's earnings from oysters, the heavy mullet population and, for a time, turtles. J.M. Murphy wrote in the *Outing* magazine of November 1890 about

the turtler [who went] *down the coast by the mangrove, from Cedar Keys southward...The fleets of Cedar Keys and of Key West will plow the main and the reefs of Anclote and Sarasota Bay...Scores of boats and vessels and hundreds of men are engaged in the trade, for here are the best turtling grounds in the world, and profitable, too, in the main.*

Murphy added that turtle eggs were also collected along the shores south from Hog Island in the Cedar Keys.[26]

A day's work did not end for the men who farmed the ocean with the sale of their harvest at the Cedar Key docks. There were nets to be mended, for example. Those who hunted the green turtles, swimming in shoals, often had nets one hundred feet long. All fishermen had other tools, including harpoons and poles.

The men in the fish houses could often count on working beyond nightfall, taking in a fishing crew's haul. These fish houses formed a group of wood buildings atop wharves built into the harbor. Bobbing nearby were the vessels docked by fishing and sponging crews. The fishermen often had new money to spend at the few shops along Second Street. William Delaino, born on Scale Island in 1882, was learning, like his father, to make a living any way he could. His father knew fishing, oystering, caulking boats, pruning grape arbors, raising vegetables at home and taking care of a few chickens. His young son started fourth grade when the Delaino family moved to the big island in 1894, and the boy worked summers packing cedar slats at a mill. For that work, he earned $0.35 a day (2009, $14.70). Now that William was "the boy" on his brother-in-law's fishing crew, his income had improved. For an earlier trip of perhaps two or three weeks, Delaino's share of the income was $10.00 (2009, $420.00).[27] He had purchased three pocketknives, which became tools—he would use them to mend nets—and a ten-gallon white pine bucket in which he stored his clothing and "a very good pair of shoes."[28]

The spongers had money, too. A.J. Arapian's newly constructed warehouse had opened, and the owner, a Greek known in Key West as "Sponge King,"[29] had filled it with sponges harvested from the bays around the Cedar Keys. The spongers were different men, in some ways. For the most part, spongers who came to the Cedar Keys–Suwannee River area were not local. The crews were made up almost entirely of black men who came from the Bahama Islands and Key West after the discovery of Gulf of Mexico sponge beds in the 1880s. Not until 1905 were skilled Greek divers to be recruited to Tarpon Springs. That community, between Tampa and Cedar Keys on the Gulf coast, was already developing and would declare itself "sponge capital of the world."[30]

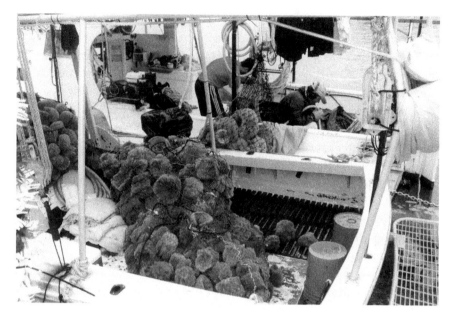

Home is the sponger. *State Archives of Florida.*

These were the good old days for the coastal communities between the Suwannee River and Tampa.

Near day's end on September 28, many vessels were in and near Cedar Key harbor, including a large sailing ship, the *Luna Davis*. In the coastal waters north to the Suwannee River were at least two steamboats that ran between Cedar Key and Branford on the mainland, the *Belle of the Suwannee* and the *C.D. Owens*. Jason McElveen has named three steamboats rigged to haul logs only: the *Octavia*, the *Helen Derium* and the *Kevin Kennedy*.[31] During this Monday, as many as twenty crews were known to be diving for sponges along the coast. Their small vessels accommodated the crews much like Captain McCleary's houseboat, although space in the spongers' sleeping quarters was sometimes appropriated to store a great haul of sponges.

Marbury, the Atlanta weather observer, followed the Number 4 storm on September 28. He wrote, "At 8 o'clock p.m. its center was very near the northern coast of Florida, and was preceded by increasing cloudiness and rain as far north as the coast of North Carolina."

At Atsena Otie, Velma Crevasse admired the sunset. The ten-year-old was later to recall that the sun became a brilliant red at the horizon and that an unnatural calm settled over the islands early that evening. The family custom

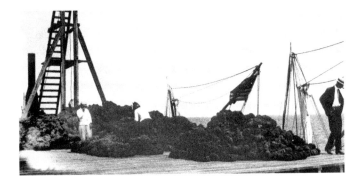

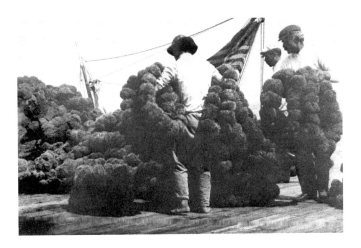

This page: Greek divers became a main force in sponging at Cedar Keys in the early 1900s. *State Archives of Florida.*

was to retire early, and they did especially that evening because Velma's father, a schooner captain, planned to sail to Key West in the morning.

Nicodemus Wilder also remarked on the sky: "It seemed just like something that we had never seen before. But there seemed to be nothing to be alarmed about…If we had known what was ahead, we would have turned back for home at that point."

Anchored for the night, young William Delaino recalled:

> *There were plenty of fish, but they acted crazy, which was unusual. We had no way of getting weather reports, and we knew nothing of the storm coming. In those days, the old folks would come out, look around, and say, "Well, we're going to have a Northeaster (or a Southwester)," and that's all there was to it.*

The McCleary crew was settled that Monday night about a mile southwest of the Suwannee River's West Pass. Delaino said he knew of two boats that had set anchor for the night at the mouth of the river, about a mile away. "It was very calm, and their voices carried a long way," he recalled. These crews were hauling freight from Cedar Key to Blue Creek. One boat was captained by Barney Russell and the other by Sam Register. "There were probably more men in the crew,[32] but I do not know their names or how many, but on the night of the twenty-eighth we could hear them talking." No doubt, then, the crews almost into the Suwannee could hear Delaino and his group. "We had our supper," he said, "and sat around and told a few lies and then went to bed."

On Bradford Island, not far from the McCleary crew, the James W. Beacham family had been aware of strange tides. Beacham was quoted later as saying:

> *The wind first blew hard offshore for a day or two, so that the sea retreated to the far horizon and vast mudflats were exposed. This was something you couldn't walk through, and you couldn't run a boat through it either. The people on islands up and down the coast simply had to stay put and wait for whatever was coming. Those who could get there came to Big Bradford, for it was the highest island and [Beacham's] house was sturdy.[33]*

Mr. G. Merritt of the firm of Merritt and Power, turpentine distillers of Fort Fanning, near Cedar Key, told an Orlando newspaper reporter his story, which appeared in the October 10 *Times-Union* of Jacksonville. He said, "When the storm began, the clouds seemed to lie near the earth, and

rolling like a huge cylinder. The light of day was almost obliterated, and it appeared to be between deep twilight and dark."

Nicodemus Wilder knew Florida and Gulf of Mexico weather. He had been boating on the Suwannee River and near Fort Fanning all his adult life. He could recall a month-long fishing trip when he was about nineteen years old, in 1869, living in a camp he built with another man twelve feet off the ground, above high tide, on an island near Cedar Key. The fishing was successful. "As soon as we would get a barrel full salted down," he said, "we would carry them to town and sell them, and then buy whatever we needed." Later that year, he went to work at a Cedar Keys mill, and his life from then on was always in and around the Gulf and the river. This September 28 trip was to be very different from any others.

Nick remembered the 1896 storm's warning as follows:

> *We were now well on the way to the mouth* [of the Suwannee River], *and I did not realize that I had not given one thought to the weather for the trip. I was on the Suwannee Bay when the hazy weather turned into another '75[34] storm. This was much greater than you can imagine by just reading it. Jim and I had our two light cypress boats plus our possessions and was well on our way to Cedar Keys when this all started. This was mean waters under normal conditions, but this was a storm.*

Young William Delaino was also aware that something unusual was happening. After supper on their houseboat, the four men were up again about ten o'clock that evening, alerted by "a breeze." Over the next two hours, while they drank coffee, they were to sense the potential for trouble. "At twelve o'clock [midnight], it was blowing a gale," Delaino recalled. "Our small boats were beginning to take on water so we got in them and tied the oars down and the sails down good into the boats. We had net racks built out in the water that we dried our nets on." Despite the wind, the crewmen returned to their bunks until "the boy in camp" had breakfast on the table.

A "screaming wind" awakened Velma Crevasse about three o'clock that morning. She was in a bedroom of the family's Atsena Otie home. As windows on the front wall were being shattered by the gale force, Captain Crevasse guided his wife and three children into the kitchen at the rear of the house. The huddled family watched as rain formed puddles on the floors. In the front parlor, furniture and drapes were soaked. And yet, this wind-rain storm seemed to end only a few hours later as daylight broke across the tiny island. Mrs. Crevasse made breakfast for her family, no doubt thinking about the efforts and time she would invest in returning her home to normal conditions.

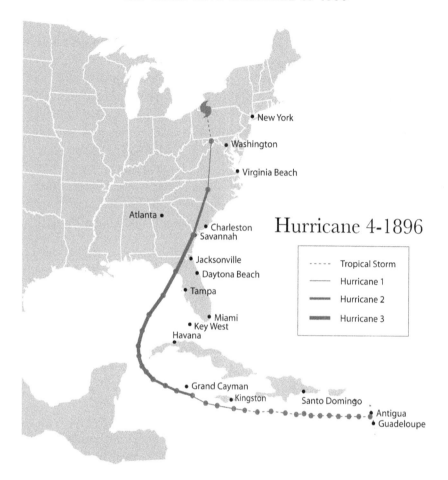

Hurricane 4-1896

-----	Tropical Storm
——	Hurricane 1
▬▬	Hurricane 2
▬▬	Hurricane 3

This map tracks Hurricane 4–1896 cutting into the Gulf of Mexico, making landfall at Cedar Keys and going north to the Great Lakes. *Stormpulse.com and Marshall Hudson.*

Camping at Geiger Creek, Yearty father and son, and Will's friend, Tom Howard, were awakened about four o'clock Tuesday morning, September 29. Will later wrote:

The wind was about forty miles per hour. By daylight all the timber, large oaks and pines, had blown down. We thought we could go down to the landing and, as the water came in, bring the boats up to higher ground. Our camp had blown away, and we had to build a fire in an oak top. Dad came from the oak to look around and noticed a streak of light in the northwest. He called to Tom and me, "Boys, the wind is calming; let's go for our boats."[35]

"This Was a Storm"

Out on Bradford Island, the Beacham family and their "sturdy house" were meeting the ultimate challenge. A Tennessee writer recounted the events that he said James Beacham had described for him:

> *Then the wind swung around and the piled-up water rushed back onto the coast. It covered the island and kept rising. It became deeper on the floor of the house and the people climbed onto tables; it kept rising and they chopped a hole in the roof and climbed out on top of the house. Then the house suddenly collapsed under them and they were in the rushing water. Beacham grabbed an object which turned out to be the garden gate and then abandoned that to cling to the high fork in the tall cypress tree. About twenty-four hours later, some men came along in a boat looking for survivors. He was the only one they found.*

Nicodemus Wilder recalled:

> *This kept up all night. When day came, you know as much about where we were by reading this as we did in reality. The storm had completely destroyed any course that we could have taken. We figured that we were in the Gulf of Mexico somewhere—out where, no one knew. Well, this storm kept raging like a million wild horses, all this day.*

This storm, Jay Barnes was able to state a century later, was not only powerful but also tragic. Evidence suggests that this was, in fact, a surprise storm for Cedar Keys and the Gulf Coast. The September 30 *Florida Daily Citizen*, published in Jacksonville, ran six stories in its weather section supporting the conclusion that Hurricane Number 4 had taken an unexpected path. The following is a sampling of weather reports from Atlantic and inland Florida cities on the morning that Number 4 was wrecking the Cedar Keys:

> *West Palm Beach—Several storm signals were posted here yesterday but no bad weather has been experienced yet. The wind, however, has been blowing hard for several days and the tide is very high.*

> *Lotus—The wind has been blowing a half-gale here for about four days. The weather has looked very stormy, but nothing dangerous has yet been developed.*

> *Orlando—A high wind from the south prevailed all of last night and, this morning, rains with southwest and west winds came at intervals.*

35

Sanford—The hurricane reported as coming up the southeast coast of Florida has reached Sanford, but is not assuming any alarming proportions. The wind is high and frequent squalls and rains have occurred during the day.

Malabar—Equinoctial gales have been prevalent here for several days.

Jacksonville [Headline: "The Wind Attained a Velocity of 100 Miles an Hour"]—*The storm that has been predicted for several days arrived in Jacksonville yesterday morning with a suddenness and fury that surpassed all previous records, and, for a time, threatened to devastate everything that lay in its path. The storm consisted mainly of wind, blowing with the velocity of a hurricane although a small amount of rain fell.*

The *Atlanta Constitution* was to see the storm differently. Its September 30 issue described this as the "storm which has been lurking in the eastern Gulf for the last two days." In fact, the people of Galveston and nearby Texas communities in the western Gulf of Mexico had known no more about this never-lurking storm than the people about to be swamped at Cedar Keys.

CHAPTER 3

"NO! MY GOD, LOOK THERE!"

I looked up and there was a mountain of water coming down on us.
—*William P. Delaino*

Increasing cloudiness and rain during Monday the twenty-eighth seemed ominous to some of those in the Cedar Keys. As evening turned into late night and then into the early hours of Tuesday, the outer winds and rain of the storm seemed stuck at the point where ocean meets land in Florida's Levy County. The Atlanta weather station operator recorded the center of this fourth storm of 1896 moving from several hundred miles off the coast of Florida to make landfall at Cedar Keys in less than twenty hours.

For the residents of this area of Florida, the evening breeze and unusual sundown conditions of Monday turned into a huge storm in the early hours of Tuesday. Around daybreak, the worst of the storm came like a thunder of drumbeats interrupting a funeral dirge. A wall of surging water roared in from the Gulf of Mexico, washing over the islands and marshlands and continuing along streams and creeks deep into the mainland.

Velma Crevasse screamed the alarm for her family on Atsena Otie. Young Velma would remember sitting on the outdoor stairway off the kitchen as the sun came to the horizon that morning. Then, she ran into the house, shouting, "Look at the water coming!" Mrs. Crevasse soon saw a ten-foot surge coming off the ocean.[36] She took the baby and ran with the children to the higher ground of a next-door neighbor's home. Together, they watched from a third-floor window as the pounding surf ripped through the Crevasse home, knocking it from the foundation.

The surge that had overrun Atsena Otie was evident from Cedar Key. According to a *Florida Times-Union* reporter, W.M. Anderson looked out a second-story window at seven o'clock on Tuesday morning at what seemed a normal tide. "But in an instant this was changed and a wall of foamy water came plunging over the town. Buildings went down like sticks," Anderson remembered.

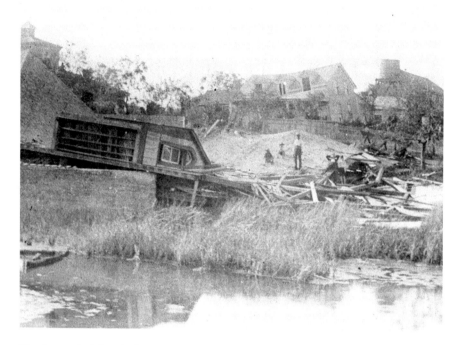

Hurricane winds knocked over shoreline buildings. *State Archives of Florida.*

The same surge was upon Cedar Key in no time. Katherine McCumber McElveen, in her interview with Lindon Lindsey, was to remember, more than half a century later, what happened on Cedar Key: "The big storm came, a tidal wave, and washed our house away when I was about three years old. No family was lost. They carried all us children to a house up on a hill."

In fact, many Cedar Key residents escaped drowning only after a dousing. "Many people floated in the water," the *Times-Union* reported in its October 2 issue, "clinging to pieces of timber; others clung to tree tops for hours, until the water receded. They were buffeted by wind and water."

In early morning darkness that Tuesday, Delaino was getting the meal ready when the captain decided that the crew would take shelter by moving into the Suwannee River. "But when it was daylight good, it was blowing so hard a man could hardly stand up, much less try to go anywhere," Delaino said. He remembered later that he prepared a meal of dry corned beef hash, rice, biscuits and coffee. Twice the crew sat at the table with the food, but both times "our [run] boat began to drag its anchor." The first time, the

anchor caught and halted the movement, but the roiling water lifted the smaller boat again. "This time she kept coming, and she came down on [the houseboat]." Delaino continued:

> *Tom Wallace and Vernon Wilson got on her, but they could not stop her. They kept on going. Our houseboat was doing fine, but those boys and that boat went on out of our sight—no breakfast. Well, it wasn't a very good feeling. Now it was eight o'clock. Our houseboat began to drag. It drug down close to our net spreads, and the camp boat got tangled in the nets and turned our camp boat stern to the wind, got in the back end of the cabin, and blew the cabin off.*
>
> *Then we got clear of everything and were doing fine...but it was getting rougher all the time. Then we dragged down on the run boat where Tom and Vernon were. We got close enough to get ahold of the anchor cable, but the Matty F. had turned over and broke her mast out. The boys were astride of the keel, holding on for dear life. We motioned for them to come over to us. Our camp boat was doing fine, but they were afraid to try it. Then we had to turn loose of them.*

The Cedar Key men camping near the Suwannee River were to become lost as huge waves carried them to unfamiliar land. William Delaino estimated the morning time at nine o'clock when he and Captain Bob McCleary, having lost the other two crew members, were drifting out to sea. They were "scrooched down in one corner of our boat—not much to say." The absence of conversation ended a couple of hours later. Delaino heard

> *something. I said, "Is that thunder?" That would have been a sign it was getting better.*
>
> *My brother-in-law looked up and said, "No! My God, look there!"*
>
> *This was the tidal wave. There were three waves. The first one filled our boat half full; the next one turned her over completely. Then we had a flat bottom to hold onto.*[37]

Describing the boat's surface as nine feet wide and twenty-seven feet long, Delaino said there was "not much chance" to survive. "The boat was traveling as if she had no anchor out at all. We would get up on her bottom and lock hands. We could reach across her bottom and hold on just a little, but the sea would wash us off and we would get back up." Physical strength, a gritty determination to survive and perhaps a little luck carried the two brothers-in-law to safety.

THE CEDAR KEYS HURRICANE OF 1896

Nick Wilder recalled:

This storm raged like it seemed to us that we was the ones that it was trying to destroy. It was using all of the power that it could find. Waves so high, it looked like a black wall coming at us, and it seemed like there wasn't any chance of us staying alive. Jim had finally given up, and just lay there as if he were dead. He wasn't dead, but I, too, finally decided to just give it up and lay down, and not fight the inevitable. This storm just raged until dark came and as far as I could tell, there wasn't a chance of us coming out alive.

The fourteen-year-old Delaino had the same fear: "I knew there was no chance for us. How I wished I could see my mother and father one more time!" But then he added, practically, "And what dirty water to be drowned in!"

After forming and festering over hundreds of ocean miles in the Caribbean and then the Gulf of Mexico, the fury of the Number 4 hurricane was finally making landfall. The wild weather that the campers, fishers and freighters were dodging early Tuesday morning was soon pounding bigger targets on the settled island of Cedar Key. Wind and rain came first. The elements had broad and high targets at every turn. Scores of buildings—homes, stores, factories, churches—nothing seemed to escape the wind. And yet, the population, counted in the hundreds, was safer there than in the exposed creeks and marshes of the outer islands. The residents had the buildings for shelter. One of the enduring mysteries of this storm is why there were few, if any, lives taken on Cedar Key.

Even before the huge wave arrived, roofs and walls were sent sailing, along with furniture and personal belongings. The speed and weight of the surge swept away the sand and shells on which stone building foundations rested, causing walls and whole buildings to crack and collapse. A reporter for the *Florida Daily Citizen* noted the irony as houses "that were built of coquina [stone] and were capable of resisting the effects of the wind were undermined by the [surge] and collapsed...Probably the heaviest loser by the storm was the Town Improvement Company."[38] The company owned many houses throughout the town, and "nearly all of them were blown to the ground. The company's loss will run into the thousands [of dollars]."

Conditions in Lake City, where Nick Wilder made his home, no doubt caused similar weather reactions throughout the region. The *Citizen* reported on October 2:

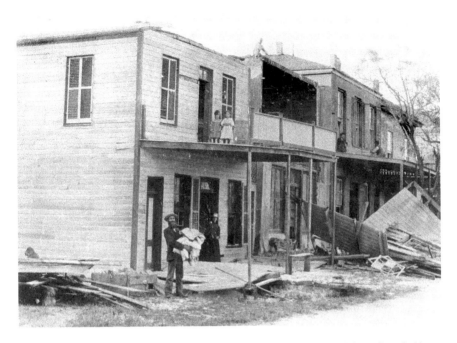

Second Street stores and apartments lost roofs and walls to the winds' fury. *State Archives of Florida.*

The wind from the advancing rim of the storm struck here about 7 a.m. [September 29] *and continued to blow from that direction for about an hour with great force and doing vast damage. When the center of the storm was reached, there was a complete calm lasting from five to ten minutes during which a number of persons noted the presence and passage of hot air, giving out almost a sensation of steam. The wind from the rear rim of the storm then came on from the west with increased fury, and this blew from that direction about a half-hour, reaching a velocity, it is estimated, of a hundred and fifty miles an hour and doing even more damage than the blow from the east.*

McCleary's overturned boat drifted for a half hour but miraculously was righted in the heavy waves. Through a heavy rain and mist, the boy saw "two water spouts." "No," the older man said, "that's land. We are going towards land."

The captain knew the ways of his craft and the sea, and he gave important instructions to young Delaino:

We have a heavy mooring anchor and a 40-pound cage anchor. When we get up on the land, that anchor will catch in the rocks and this boat will sink down. When you feel her going down, jump as far as you can to get away from the suction.

No sooner said than done, recalled Delaino. In detail, he was to describe the two of them "going with the wind and the tide," clutching logs and treetops among floating debris and "going up on the land all the time." They took a rest on three pines locked in the water's fury.

It was still blowing but we could tell that the water was going down. When we [put our feet down], the water was just neck deep, and we could tell there was a creek over there. We were way up in the swamp, but we knew not where. We thought if we could get back to the coast, we might be able to tell where we were.

In fact, the brothers-in-law had been pushed well up the Suwannee River. Riding either end of "a dry cabbage log about twenty feet long—crooked," the survivors went

down the coast toward Salt Creek, but did not know when we reached Demory Hill.[39] *When we got down to the mouth* [of the Suwannee

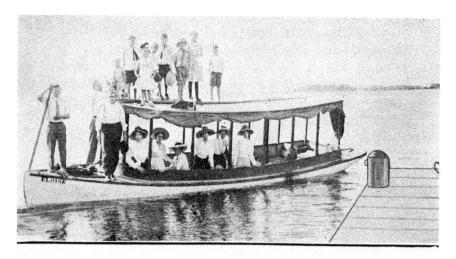

All Aboard for the Suwannee River.

Happy days cruising on a Suwannee River steamboat to Cedar Key. *State Archives of Florida.*

River], *we saw our camp boat. One end was up on the hill…We figured we were on what is called Lapton Island.*

Their luck seemed to be turning. They found that their houseboat had been washed up on Lapton Island, and although they did not know it then, so had their crewmates, Wallace and Vernon. Although not much was salvageable, Delaino said he was able to help McCleary, who had lost his shoes and found walking barefoot near the creek difficult. The boy's shoes were large enough and the captain wore them.

Again, they abandoned their houseboat and attempted to walk along the coastline to get to Shired Island. "We were going over and under trees," he wrote. "It was so hard on us." Their way blocked by fallen trees, McCleary and Delaino "took the straight shot to Shired Island." Tramping through marsh grass, "mostly that old needle grass," he said, "we swam twenty-one creeks before we reached Shired Island. We arrived at the island between ten and twelve o'clock [midnight] Tuesday, September 29, tired and worn out." Along the way, they had passed dead fish, which Delaino figured

came out of our boat. She had nine hundred [pounds of mullet] *iced on her when she turned over. There were plenty of river turtle, and we saw pieces of our small boats that were broken up in the storm. There were several pelicans sitting around in the trees. They seemed disgusted with the weather.*

Nick Wilder also was disgusted. He recalled:

Until this day, I will never know how we came out of it. But as the night kept going on we lived; now it wasn't any time to worry about bailing out our boat, for the waves were keeping it full, or empty, during the storm. I saw our boats in every condition that they could be in during this storm—full of water, empty of water—but still we hung on to anything that we could. At times a puff of wind would empty them, and the waves would fill them up again…The wind was getting weaker, but the waves were as high as ever. This kept up all night…It finally began to calm a little by nightfall. There would just be a hard gust of wind every now and then. We didn't know where in the world we were. For all we knew we could be anywhere.

So, this night, our sealed-in compartment [with about a week's food supplies] *proved more valuable than ever. Well, the night passed, and when day came, we were without the wind, but the waves seemed to have forgotten that the wind had ceased. But, at least we had lived to see daylight*

again. As the sun began to get higher, it was hot, but it seemed to be causing the waves to calm.

The Yearty group had camped on a rise on the west side of the Suwannee River. They had left their boat near Geiger Creek, and when it seemed the storm was quieting, Bill Yearty headed the two boys back to the water. Will Yearty recalled:

> *When I got down, I noticed the water on the west side of the hill was a solid wall about ten feet high as it was coming up the hill. We made a run for it. We ran east across a low marsh for about 200 yards to another hill. The water had covered the hill where we had camped and was already coming around on both sides of the hill we were on.*

The three were able to stay above the water level.

McCleary and Delaino surely must have felt as though they were marooned as darkness arrived on Tuesday evening. Delaino, whose account of the storm is probably the most detailed of any made public, continued:

> *The moon was about an hour high and bright as could be. We walked down to the beach, and in the sand we found tracks that were made after the storm. We kept walking and found a trail that led across a marsh to a larger island…We kept on going up the trail and found some people. The house had blown off at its blocks and wrecked it very much, but they had a fire, some salty coffee, sweet potatoes baked in the sand, but my, it was good. We spent the rest of the night with them.*

Delaino and McCleary knew the five people they had come upon on Shired Island. They included Barney Russell, one of the freighter captains who had anchored, on the night of the storm's arrival, at the mouth of the Suwannee River; and four Shired residents. Delaino called them "old coasters"—brothers Joe and Jim Starling, Jim's wife and "an old boatman, a Spaniard by the name of Decenty Pettis."

Wednesday morning brought the conclusion for McCleary and Delaino that "our chance to get home was to go to Fish Bone." This tiny community, which no longer exists, was inland, east of the Suwannee. That turned out to be the best decision they could have made. It was to bring them back to Cedar Key. Delaino said, "There was a road out of there so the [Starlings] put us across Shired Creek and we walked to Fish Bone. This was across marsh [over] an old wagon road…about five or six miles." Arriving at Fish

Bone that morning, the brothers-in-law came upon John Luther and his father. "We had something to eat and Mr. Luther gave us an old bateau kind of boat, but it looked good to us," Delaino recalled. "He gave us a bedsheet which we made into a sail, one paddle, a lunch, which was biscuits, pork and sweet potatoes, and a jug of water."

Now their luck had turned.

We set sail for Cedar Key, had a good west wind, which was almost behind us, and we made good time. I had not thought anything about the storm striking Cedar Key, but as we were going around Piney Point about sundown, we could see some old dump carts, pieces of houses and rubbish of all kinds out in the bay around Rum Key and Channel Islands. Then we began to think if our folks were lost or not.

And "the folks" were worried about Bob McCleary and his kid brother-in-law. Tom Wallace and Vernon Wilson, the other men in McCleary's crew, had landed a half hour earlier, Delaino said.

They had some awful stories to tell my mother, father and sister—what they had seen that they knew came off of our campboat, knew that she had turned over and could see no chance for us, but when they heard that we had landed, that was a happy time for us all to meet again.

Wallace and Wilson, the newcomers learned, had landed only a half mile south of their own landing place on Lapton, although they did not know it at the time. Following the sound of a man's shouting voice, Wallace and Vernon found John Pinner, who had been washed to Lapton from the nearby Bradford Island.[40] Pinner's sister, Emily Beacham, had been lost when the surge overran Bradford Island. Pinner led the way to Mandarin Point, where John Daughtery and his family offered help.

Emily's husband, Jim Beacham, told of their experiences in the storm to a man identified only as "Mr. Benton of Chattanooga." A letter from Benton, written in 1956, was reprinted in a volume of *Search for Yesterday*. Benton said he met Beacham years later when he was on a fishing vacation at Demory Creek and Beacham was "running his coon traps." He said:

Presently he pointed out a fork high in a big cypress tree. That was where, he said, he had caught on and held during the night of the big storm, the night his home was washed away and all others in the house drowned, including his wife.

Delaino learned the fates of five men who had been fishing and camping at Axe Island. Brothers Henry and George Havens and the son of one of them, Frank Havens, were all dead. The other members of that fish camp, Lewis Daughtery and Joe Hall, were saved by climbing high in a cabbage tree and embracing the bud. Delaino said that the men's "arms and chests were as raw as a piece of beef" from the rough vegetation. All of the group's equipment and supplies had been washed away.

Delaino reported also the death of Sam Gause, one of four men who had been camping and fishing on Long Cabbage Island. Delaino said that another in that party, Charles Doar,[41] lost his wife and three children and a niece and her two children.[42] They had lived on Buck Island, "just inside of Long Cabbage." Like Sam Robertson, "a man who was on the island with them," all eight of them drowned.

To Delaino, the casualties seemed to be everywhere.

SURVEYING THE DAMAGE

When mornin' cum, I took a good
Long look, and—well, sir, sure's I'm me—
That boat laid right whar that hotel had stood,
And hit sailed out to sea!

For here I walk, forevermore,
A-tryin' to make it gee,
How one same wind could blow my ship to shore
And my hotel to sea!

—Sidney Lanier[43]

H ome, finally, on Cedar Key after dark on Wednesday night, September 30, Bob McCleary and William Delaino would not get a look at the island's damage until daylight the next day. They had made note of debris floating offshore as they arrived in the borrowed skiff, but that did not prepare them for their first look at the massive wreckage on Cedar Key. Delaino wrote later: "The Schlemmer Hotel, the Bettelini Hotel, and The Bar Room burned. Fish houses washed away, railroad washed away, boats in the streets, and rubbish of all kinds. Things looked bad."

The most spectacular proof that a huge ocean surge had run over Cedar Key was the presence of a large boat far from the water. The sailing vessel *Luna Davis* had been anchored Tuesday evening in the harbor. The following morning, it was lying in the business district, "high and dry between the remains of two rows of buildings," a *Citizen* correspondent wrote. "The street is littered with debris, small boats, railroad ties, housetops, fallen trees, and every kind of furniture and household goods." Although many men were able to remove much of the debris, the schooner was still there two weeks later.

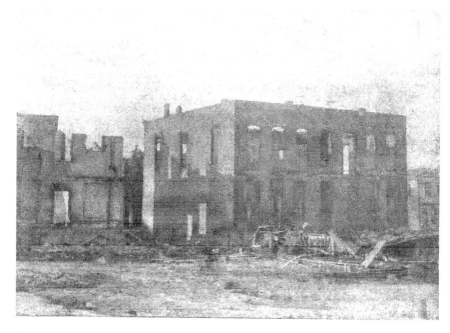

The coquina stone walls of the Bettelini (left) and Schlemmer Hotels were all that remained after a fire during the hurricane. *Lindon J. Lindsey Photo Collection.*

Perhaps no less spectacular for those witnessing the scene with no advance knowledge of the damage was the sight of Cedar Key's hotels. "The most damage was caused by the fire in the center of the city," the *Citizen* reported. The story continued:

> *The fire began in the Bettelini Hotel. The portion of the house used as a kitchen was a small wooden addition. The chimney of the place had blown down, and caused the flames to fly from the stove on every side. The interior of the kitchen caught first, and the wind soon fanned the fire into a huge blaze. The hotel proper then caught, the residence of Mr. Sorrell going next, both being completely gutted. Mrs. Sorrell was very sick at the time, and had to be carried from the house while the flames were on every side and the limbs of trees and parts of boards were falling thick.*
>
> *The Schlemmer House was the third building to catch fire, and was a total loss. This hotel was one of the most handsomely furnished hostelries in this section. Not a portion of furniture was saved. [Both hotels] have been completely gutted and everything contained in them was lost.*

> *The loss to the Bettelini Hotel is estimated at about $8,000* [2009, $336,000]. *The loss to Mr. Sorrell was about $2,500* [2009, $105,000], *while that sustained by Mr. Schlemmer is not less than $12,000* [2009, $594,000]. *The buildings were not insured. The Schlemmer House will probably not be rebuilt, as it represented the entire savings of seventeen years, and the owner is now almost penniless. The walls, although they look substantial, are cracked in places, the sand foundation having been washed away. Both hotels were very substantially built of coquina and would have easily withstood the force of the wind.*

The *Atlanta Constitution* report on October 2 added:

> *The inmates saved nothing, so fierce and sudden was the fire, and with roaring flames above, and raging flood below, they were too badly frightened to attempt more than the saving of life. They made their escape by wading through four feet of water.*

By far, the greatest individual losses were in the center of the city around Second Street, the community's main street. The surge came in eight feet high, by most accounts, and flooded every store. "The streets that cross Second Street show the force of the receding water, as they are full of hollow places from two to eight feet deep and filled with water," the newspaper reporter said.

Cedar Key had taken great pride in having sidewalks constructed along both sides of Second Street, enabling walkers to avoid the dirt street. Now, every walk on Second Street had been washed away. The city hall was

> *badly damaged, although it can easily be put in shape. All of the windows were blown out, and floating timber broke the doors, and, together with the rushing waters, demolished the furniture of the building. The interior is now a mass of debris.*

The *Citizen* also reported the high school "destroyed" and the post office "somewhat damaged."

The newspapers of Tampa, Jacksonville and Atlanta carried detailed reports of the damage throughout the business district. The following is a summary of the conditions of the major businesses as noted in the newspapers:

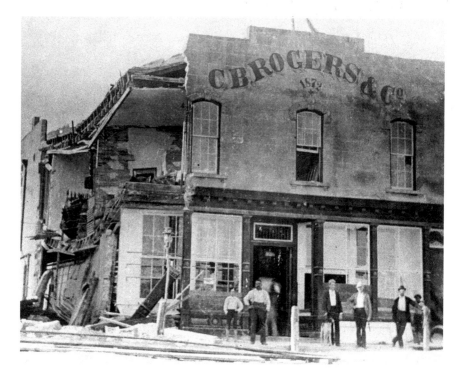

C.B. Rogers & Company after the storm. *State Archives of Florida.*

C.B. ROGERS COMPANY

The large coquina building, which cost $8,000 [in 1872; 2009, $336,000] *to erect is a total loss. The wind did not affect this much until after the rushing water had cut away the sand beneath its foundation. This caused the side to collapse, after which the wind completed the wreck. The water passed through the building and ruined most of the stock. The interior of the building has been propped up, but the roof is damaged, and the entire structure is full of cracks, and it is momentarily expected to crash to the ground. It is estimated that the loss to the company will easily aggregate $12,000* [2009, $504,000].

W.S. WARE ICE FACTORY

"The worst looking building in the city," the ice factory condition was caused entirely by the wind. The building had been put in "perfect condition, and a new boiler was placed in position." The boiler was all that was saved. The building's corrugated iron and tin "was blown in every direction." The *Citizen* wrote:

Surveying the Damage

The Waldo branch of the same factory has been closed for some time, and the indications are that this branch will be opened and the local branch abandoned. This will throw many men out of employment and take one of the chief sources of revenue from the city.

COTTRELL & FINELSON
The warehouse and contents were a total loss; the store was "still habitable, although the stone walls are cracked, and the wind has carried away more or less of the building." The loss was estimated at about $2,000 (2009, $84,000). The *Constitution* reported that the firm's "boathouse was blown down…and [it has] lost several boats."

PARSONS & HAILE'S GENERAL STORE, which backed up to the docks, "was partially destroyed, and the damage is estimated at $1,000 [2009, $42,000]." The firm's "warehouse was unroofed and much stock [was] damaged," the *Constitution* added.

F.C. HAILIE's place was inundated, causing the wall of the building to "crack to a dangerous degree."

ARAPIAN WAREHOUSE
The recently built large warehouse "was washed away and nothing remains to show where it stood. The building was filled with sponges, and they were all lost." Arapian's main business was on Key West, and his Cedar Key building was, in effect, a holding station. Kirk Munroe reported that Arapian's "annual sales aggregate half a million of dollars [2009, $21 million]."

McCULLOM'S AND O'DONALD'S DRUG STORE, on Second Street opposite the Schlemmer House, was built of coquina. When the foundation was washed away, the building front cracked. The wind blew the upper story out.

The *Atlanta Constitution* also listed among the damaged businesses:

E.F. O'Neill and G.M. Sistrunk, general merchants…unroofed and have had to move. S.W. Carroll suffers a total loss of storehouse and stock. In fact, not a business house or residence in the place escaped without some injury.

Cedar Key's many businesses based on wood products suffered severely. Local historian Lindon Lindsey said that the total loss of the Eagle Pencil

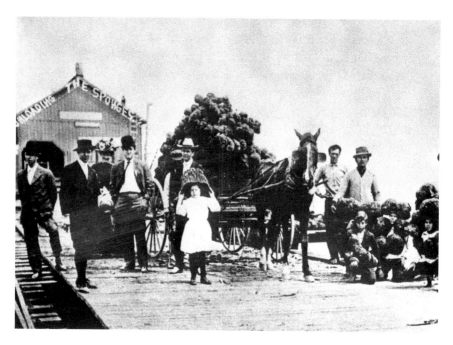

Spongers unload at the Cedar Key dock. *State Archives of Florida.*

Company factory building on Cedar Key ended its work there.[44] Eagle had purchased cedar stock from various sawmills in the islands and on the mainland for use both at the local plant and in the New York factory. Often, a shipment of wood had arrived at the beach at the foot of Third Street, floated by a mill crew. Eagle employees had equipment that converted the wood and other products into "lead pencils" sold around the world. Blasted by both wind and surge, much of the Eagle building was shredded and carried out to sea.

At the Faber Mill on Atsena Otie, Henry Schmidt, general superintendent of the works, said he would divulge nothing and that all information regarding the condition of the works must be obtained from the New York office. One of the men employed at the factory said that he was confident that the loss to the works would be at least $30,000 (2009, $1,260,000). A *Citizen* reporter noted:

> *The chief loss is from 1,000 cases of cedar, each case of which was valued at from $9 to $40 [2009, $378 to $1,680]. The works are in fair condition, although the effects of the wind and water are visible. It was impossible to see the interior, but one of the hands said that it was in fair condition.*

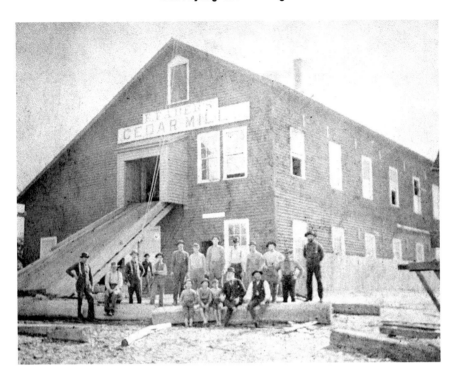

E. Faber millworkers pose at Atsena Otie before the storm. *State Archives of Florida.*

A *New York Times* story gave the loss of cedar ready for shipment at three thousand cases, all washed out to sea, as well as the storage room, office with contents, wharves and cedar logs.

The *Citizen* continued its Atsena Otie report:

> *The island contains about 100 houses whose inmates rely solely upon the factory for sustenance. Mr. Schmidt has informed the men that he has not as yet heard from the New York office of the company, but said that in the event of the works being continued they would be put to work rebuilding. This would give them an opportunity to make sufficient money until the works should be opened. The men doubt, however, that any such order will be given. Their reasons are that the wind and waves caused $40,000 [2009, $1.68 million] worth of damage, mainly on account of the large account of cedar lost. Another reason is that the salt water is very hard on the machinery, which costs much to be kept in proper trim. When the works opened, cedar was in abundance; but at present there is none in the vicinity, and it is now being shipped from Sanford to Jacksonville, and from there to this place. The men hope that the factory will be reopened somewhere in*

Stacked wood posts represent the heavy production at the Faber Mill. *State Archives of Florida.*

the State, either at Sanford or Jacksonville. In that event, they hope to secure employment; otherwise, they will be in a sad predicament.

The gloomy prediction was only slightly inaccurate. Faber's Atsena Otie building was repaired and continued in operation another two years, according to Levy County historian Lindon Lindsey. The stripping of cedar from the islands and mainland since the Civil War had left the mill without the supply of special wood it needed. In fact, Faber's pencil factories in New York and at the home plant in Germany were looking for new forest stands.

Another storm victim was F.A. Wolf's mill. It was one of "several mills that have been cutting cedar for pencils and pen-holders for the Faber works." Wolf's brick building "was totally destroyed." Wolf's factory had special saws for the cutting of cedar pencil slats. Mr. Wolf told a *Citizen* correspondent that "he believed that he would not again engage in business."

The *Constitution* added that "the large lumber mill of V.J. Herlong and the planing mill of George W. Moyer & Sons, just complete and ready for work," were destroyed.

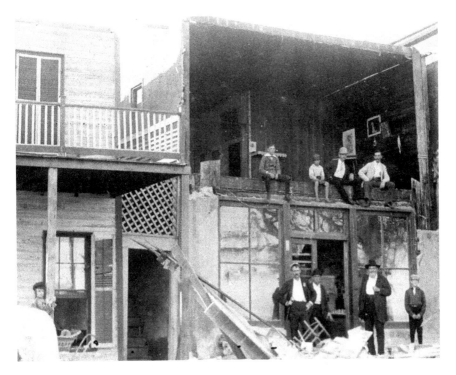

Residents pose in the ruins of their home. *State Archives of Florida.*

Church buildings suffered greatly. The *Citizen* listed as destroyed the Christian church, "which is a new building," and the Methodist church. Damage to Christ Episcopal Church, founded in 1876 in the former Union church and schoolhouse and enlarged in 1882, was an especially major blow; the parish had only ten families. Buildings "on the hill" were protected from the surge, but, the newspaper continued,

> *the wind asserted itself in a forcible manner. The colored Baptist Church, which is almost a new structure, and the pride of the colored population, is a mass of ruins…In the highest part of the hill, the roadway is completely blocked by fallen trees and debris. The colored Methodist Church on Seventh and G streets is also a mass of ruins. Numerous small houses were blown to the ground at this point. The Odd Fellows' Hall is a wreck. It was not blown down, but it was blown from its foundation, and was deposited a short distance from it in such a manner that it is resting at an angle of about eighty degrees. The walls are bulging on each side, and it will be necessary to tear it down.*

The Yearty men and Tom Howard had managed to get on a hill near the Geiger Creek to escape the surge. "We had just made it to the high land ahead of the wall of water," Will wrote. Their boat gone, they walked six miles and came into Cedar Key to discover damage all around. "The first house we passed," Will said, "was the Baptist church, which was blown down."

When the hurricane's high winds and water had slowed sufficiently, the Crevasse family left their neighbors' home and returned to their own place on Atsena Otie. Velma Crevasse would recall that the house was tilted by wind off its foundation. Inside, they found new damage—to their furniture, books, dishes and personal belongings.

Getting home after the storm was to be as much an overland adventure as was the storm at sea for Nicodemus Wilder and the man he called Jim Reeves. Sunrise and the storm's end found them with "more will to live," Nick wrote.

At any rate, the waves ceased, and then it was the most beautiful morning. I longed to go back through the storm just to have the same feeling about this morning again. If a person hasn't really needed something in life, they wouldn't know what I am talking about. Now we were longing for the safety of my shack, or home, or anywhere off of the water. But there was no sign of anything but water, and the protrusions that would appear out of the water. Then, in a while, a bird would fly over.

Of course, we had no way to tell how to reach land. But that was our aim…So, we started to head our boat to what we thought might be land, and we kept this up all day. When night came, we were still not in sight of any land. We were also dog-tired, and so we attempted to anchor but we had nothing to anchor to. So we kept control of the boat by one of us at a time guiding us until daybreak again. When the sun was up in the morning, we were not in sight of land, but we were a bit fresher and kept our course as we did the day before. The day was far spent when we saw that we was heading to land of some kind. But we didn't know where. When it got dark, we were close enough to know that we could reach it in a bit. At eleven o'clock that night, we had reached the marsh, and it wasn't hard to find a creek to get us to dry land. No man can know the good feeling, until he has this need, of getting onto dry land again. We built us a fire and began to dry our goods and prepare us a meal of what we had left. After our meal, we bedded down for the night.

The next morning, the sun came up too soon for the both of us, but at least we could walk some and not fret for awhile. So, we started out across

the swamp with our gun. This was the most horrible thing of all. There was just swamp birds, and wild of every kind, and destruction of the land. It seemed that the Lord had changed from kindness to evil, as man had done. But, we kept our faith and we would cut a tree or scrub as we went along to mark our way. About three o'clock in the afternoon, we came to a road that had been used by a wagon and a pair of horses, and it was leading in the direction that we had figured was the way back to the coast.

It wasn't long before we found a house and there was no one there. Someone had been there since the rain, but had left. The tracks of the team kept going on so we went on. Along about night we found a grove of oranges.

Nick Wilder told of the decision to make camp for the night, eating from their camp provisions "just a small amount of bacon and meal for each of us," oranges that had fallen from the trees and a "cake of talor."[45] He added:

The next morning, we found out that we were mighty close to some family of some kind. But, when we found this house there was no one there. It was a log house and the logs were still there. But it had no top. It seemed that someone had been there the day before. There was a bed of hot coals which indicated that someone was there cleaning up after the storm.

The men decided to rest there and were pleased soon after when "people came." The travelers were told they had been swept half the distance from the Gulf of Mexico to Ocala, a community inland from Cedar Keys. A team of horses owned by "Preacher Fleming" took Nick and Jim to Ocala, and the next day they traveled by train to Lake City. As Nick described the trip:

There was rubbish, and limbs, and such on the tracks, and we would all have to get out and help move the stuff, so that the train could go on. And several times, we waited while the construction crew rebuilt places that had been washed out.

Finally at home in Columbia City, Nick learned from "Mr. Drew" that his home had not been damaged by the storm, but when he observed "plenty of timber on the ground," Drew blamed it on the turpentine operations. He explained, "Saw logs don't stop the small trees from coming back and turpentine does."

Nick also noted:

This was the year that thousands of pine timber was destroyed in the storm, and as if that wasn't enough, the cold did its share of destruction... I would say that the winter [ice storms] *did more harm to the trees than the wind and fire had done this same fall... With the tops gone, when the* [1897] *spring finally did come, the trees were bled to death, or the worms would finish them off.*

CHAPTER 5

WATER, WIND AND FIRE

The damage done at the keys was caused by the three elements.
—Daily Florida Citizen, *October 11, 1896*

On October 11, almost two weeks after the storm's landfall on the Cedar Keys, the *Florida Daily Citizen* devoted an entire page to the islands' losses. It began:

> *The damage done at the Keys was caused by the three elements—fire, water, and wind. An eyewitness said that the wind came first, and was immediately followed by the water, and then suddenly the fire broke out. Which did the most damage is hard to tell, although the wind was the original cause of all. The wind caused a tidal wave which swept the island, with the exceptions of the high places. There the wind demolished all buildings that were not perfectly solid, and a number of these buildings was blown from their foundations...*
>
> *The wind came in gusts or waves, blowing at a terrific rate, diminishing in force the space of about a second, and then continuing with renewed force and energy. One of the peculiar things that [a survivor said] he saw was the removal of shingles from a house. He said that instead of blowing the entire roof from the house, the wind took the shingles off singly, and they resembled a flock of birds in their flight.*
>
> *So far as known, twenty-four lives have been lost. Fifteen bodies have been recovered, and the others were probably carried out to sea.*

Outer Islands

The most damage done by the storm in the vicinity of Cedar Keys was on the numerous islands in the vicinity. In every case the water completely submerged every one of them, and carried away what the wind left behind.

The islands that were damaged most, and on which nearly all of the loss of life occurred, were Shell Mound, Deer Island, Cat Island, Rattlesnake Island, Axe Island, Black Point Island, Bettelini Island, Lone Cabbage Island, Scale Island, Kiss-Me-Quick Island, and numerous other smaller islands.

The water completely cleared out these islands, and those who were successful in saving their lives had very thrilling experiences. One man saved the lives of his wife and father and his own by placing his back to the tidal wave and facing a sapling, holding one of the persons in each hand. One of the residents of Shell Mound came to the keys yesterday and showed where the friction caused by the moving of a small sapling that he had hugged removed the skin from his arms and stomach, and laid the flesh bare. Nearly all of those who were saved clung to saplings. They did not go near the trees with large trunks, as they were invariably blown to the ground by the wind.

The flexible cabbage palmetto was able to withstand the fury of the wind but its frowzy head was blown off in almost every case. One small island had a number of these trees, and they look, in their bared condition, like so many telegraph poles. The stately pines that remain in small numbers are growing at an angle. The reeds and marsh grasses in the neighborhood are lying flat on the ground.

Timber

All through the timber districts all roads are blocked, and the only approaches are by way of the Suwannee River. One of the great dangers that menaces the residents of the section is the turpentine timber that has been boxed. On each of these trees that has been treated is several inches of scrape. This is nothing more than turpentine in its crude form, and it is exceedingly inflammable. It is feasible that this might become ignited, and with all of the trees on the ground a raging fire would result. This would cause a great loss of life.

It was at first supposed that most of the timber could be cut and used by the lumbermen, but it is in such a bad condition that none of it can be saved. Many small trees block the path to the large ones that could be cut, and it would cost twice as much to get the lumber out of the tangle than it would to get it in the usual manner. In the vicinity of Fanning, Judson and Trenton, where the fine timberlands in the state are situated, there are not more than 100 trees to the acre, and this is a liberal estimate. It is impossible to get to any of the interior points.

Fishing

The oystermen will have to abandon their vocation in large numbers, as the rush and swirl of the water has caused nearly all of the oysters to be buried in the sand. This will cause a drop in this business, which was one of the chief industries at this season of the year. Few oystermen have boats, as they were nearly all blown to sea.

A few fishermen will be able to continue their work, but as a rule they have lost their larger boats, which can be seen on sandbars lying on their gunwales and floating about bottom up.

Transportation

FLORIDA CENTRAL & PENINSULA RAILROAD

Service "terminates three miles" from Cedar Key. The *Atlanta Journal* reported on October 1 that the "railroad will be compelled to build an entire new track for a distance of four miles." The *Citizen* added:

To get to Cedar Keys from the terminus of the railroad is not a very pleasant undertaking at present. During the past week the tide has been very low upon the arrival of the train from Jacksonville. Those desirous of crossing were compelled to take a negro to carry them over the places where the water was deep, or remove a portion of their clothing and walk three miles through wet sand and water. The railroad bed is completely wrecked. For several miles not a vestige is visible of what was a high embankment [carrying tracks that] originally connected the city with what is known as No. 4. In 1890, this bridge was filled in with sand. A portion of the sand was washed away in the storm of 1894, and it cost $30,000 [2009, $1.26 million] to rebuild it. At present the entire embankment and trestle is washed away, and it is estimated that the least amount at which the damage can be assessed is $80,000 [$3.36 million].

As the traveler passes over what was the roadbed, portions of the rail can be seen sticking upright in the sand as far as half a mile from the line of the road. In other places, long sections of rails on steepers can be seen sticking in the sand at right angles to the line. Much material was lost, as the ties floated away with much of the rail. As far as a mile away from the roadbed can be seen long sections of the road resting high and dry on small sand bars.

At one place where rock was used in the cribbing, the bed remains, but this is a small section. The force of the torrent that washed the road away

from each end of this section can be judged where the rails on each end are twisted to such an extent that they resemble huge corkscrews.

The fact that the stone-cribbed portion of the bed has remained causes many to believe that the roadbed between No. 4 and the Keys will be filled up with stone, as the company had plenty of this material in the vicinity of Early-Bird [island]. *It could easily be brought to this place.*

The fact that many of the business firms are considering the advisability of discontinuing business at Cedar Keys has caused many to fear that the road would not be continued between No. 4 and the city, but the large gangs of men at work on the line have allayed their fears.

Little remains of the railroad station at the Keys. Freight cars are lying about in disorder, and rails and ties are resting in every conceivable shape on whatever stopped them. An abandoned steamer has been the resting place for a large section of the road, which is lying upon the top of the steamer in such a position that its removal will be almost impossible.

STEAMBOATS FROM BRANFORD

It is doubtful whether the line of steamers will be continued between Branford and the Cedar Keys, as one of its chief sources of revenue is the transporting of naval stores. As all of the trees in the section have been blown to the ground, this branch of the business is crippled. The transportation of cedar is also a thing of the past, as the few that remained of those hardy trees have been felled to the ground by the fury of the wind.

The *Belle of Suwannee* was reported at Atsena Otie "in a very bad condition. Both smokestacks were blown away and the side of the steamer was blown in." A pile of debris from receding waves covered it when it was seen by a *Citizen* correspondent, and it was thought at the time that it could never again be used. Later, it was more thoroughly inspected, and "it is now believed that it can be saved by being immediately repaired." The *Belle*, another report noted, had been used to tow log rafts into Cedar Key from the Suwannee.

The *C.D. Owens*

is lying at the mouth of the Suwannee on a mud bank, where it was blown. It is in a worse condition than the Belle. *The* Belle *will immediately be placed in condition, and it will tow the* Owens *to Cedar Keys. The* Owens *will be placed in condition to proceed to Jacksonville, where it will be thoroughly repaired.*

Wrecked foundation stones mark the site of the once busy Faber Mill on Atsena Otie.
Author's photo.

Two other vessels were reported disabled: "The schooner *Gertrude* is dismantled and abandoned fifteen miles south of Cedar Key [and] the *Mallory* is fast in a Suwannee River swamp."

The schooner *Rosalie*, with a crew of twelve, was reported lost in the Gulf by four survivors who arrived at Cedar Key in a dinghy.

Farming

Huge financial losses came to farmers because of the Number 4 hurricane. September is harvest time in the South, as it is in many regions, and many farmers had not begun working over their cotton fields and collecting the fruits and vegetables they had nurtured throughout the summer. "Sugarcane is everywhere prostrated," the *Citizen* reported. Baker County, in an appeal for help, noted that most farmers were now unable to pay local merchants for fertilizer and merchandise they had bought with the understanding that they would pay up with the sale of their crops and animals.

Livestock everywhere was killed by falling buildings or simply vanished from pastures. Saving the family hog farm was the first concern of the Yearty family. Will wrote:

> On arriving home, we found Mother safe and she had already sent my brother, Gene, to Rosewood to get a family of Negroes to rebuild the fence… which covered a fifty-acre field…Dad wanted it built eight rails high, as he had sixty head of hogs on peanuts…We were able to finish this job by midnight and didn't lose one hog.

Hogs were seen as brightening the outlook in Judson and Trenton even though "very few buildings are left standing" in those communities. The *Times-Union* reported on October 6:

> There is no immediate danger of starvation at Judson and Trenton, as the people have hogs, and in most cases, their corn crop was gathered and safely stored, and they can easily subsist on the Florida cracker's delight, "hog and hominy"…They are all cheerful, however, and are thankful that their lives were saved.

Schools and Churches

Ellzey, a mainland community nearest Cedar Keys, experienced the same schoolhouse problems as most other places. The school had been in session on Monday, but Tuesday's storm ended classes until repairs could be made. The Methodist church was demolished, and the Baptist church was badly damaged at Ellzey.

People

Living conditions immediately after the storm were difficult for all residents in the Cedar Keys. The surge had dumped salt water, dirt and debris into "all of the wells in the lower portions of the island…Persons living in this district must travel some distance to get water to drink," reported the *Citizen*. Ironically, one of the islands' odd natural resources was the presence of fresh spring water emanating from under the Gulf seawater.[46] Citizens were complaining, too, about water moccasins, which they believed had been brought ashore on Cedar Key from adjacent islands. A *Citizen* correspondent

noticed a number of them while walking along the beach: "An old resident said that he had never seen them in such numbers before, and said that they were brought on floating debris. The bite of this reptile is very poisonous."

Heroism was recognized by the *Florida Times-Union* in an October 8 story headlined, "Cedar Key's Condition." It reported:

> *The people here do not expect a train for a month, though the railroad has a large force of men at work. Everything is boated to and from No. 4 in small skiffs: mails, passengers, and express...The accommodating agent, H.M. Oesler, does not spare himself in his efforts to reduce the discomforts of the public to the lowest possible point. He goes twice a day to No. 4 and has carried his battery out and established telegraphic communication with other points. This is a grand convenience in the midst of the depredation.*

Much of the Cedar Keys' bad news was not known beyond the islands in the first two days after the storm. All trains had stopped and telegraph wires were down. The Plant System railroad line,[47] the *Citizen* reported on September 30,

> *had a large force at work from High Springs south, cutting trees from the road. It took them all day to go four miles. The pay train, which went as far as No. 4, about three miles from Cedar Keys, returned tonight. The crew could not say what damage had been done to the town, but it is feared that it is great.*

The Number 4 hurricane was not done with Florida when it left the islands. Beneath the headline, "Fearful Story From Florida," the October 3 *Atlanta Constitution* neatly summarized what had happened:

> *In five and a half hours, the hurricane had devastated six populous counties and was gone up the Atlantic coast on its mission of wrathful, wanton destruction. Six hours after the storm entered the state the sun was shining as it can only shine in Florida, but it was shining on one hundred or more corpses, scores of wrecked towns and villages, devastated rural districts, and 12,000 homeless men, women, and children.*

The loss in timber alone was huge. D.G. Ambler, a Jacksonville relief committee member and lumber company executive, surveyed the damaged region and estimated that "5,000 square miles, or 3,200,000 acres of timber are ruined completely." The monetary loss was estimated at $1.5 million (2009, $63 million).

A report shared by several newspapers on October 1 covered most of the Florida communities northeast of Cedar Keys. In Levy County, one Williston citizen and six convicts at a nearby turpentine farm were reported killed. Baker County was badly damaged, especially the towns of Macclenny, Sanderson, Glen St. Mary and Olustee. Six dead were counted at Columbia City and "a number" in Alachua County. Lake City, near the residence of Nick Wilder, had six dead, including two children. Convicts assigned work at "Judge Richards's turpentine farm" were killed by falling trees. Two children were killed when their family home collapsed at Welborn.

In Gainesville, H.G. Mason announced a survey of concern to Cedar Keys loggers: "The timber interests are ruined, and not a tree suitable for a saw-log remains between the Waccasassa and Suwannee rivers."

Enterprisers were soon at work among the twenty-two turpentine distilleries between the Cedar Keys and Lake City, "and not one of these will ever run another charge," the *Atlanta Constitution* wrote. Within a week of the storm, L.O. Garrett was negotiating with equipment owners and experienced hands to relocate to his Orange County property near Orlando. "Mr. Garrett owns 60,000 acres of sound yellow pine timber, which has never been touched with an ax, and it is believed he will succeed in locating many stills in Orange." Some of the Merritt & Power distillery workers might have welcomed the change. Merritt told of pulling one of his employees "back into the house. The wind ripped his coat from skirt to collar." He added: "When I saw the storm coming, one of my boys ran to get the horses out of the stable, which stood near some trees. Just as the boy led the horses out, a tree was blown across the stable, completely demolishing it."

Much the same losses were being tallied in the mainland areas around Cedar Keys and Levy County. Under the headline, "The Storm in Bradford," the *Times-Union* reported on October 10 from West Bradford:

> *Saying nothing of the loss of personal property, it is heart-breaking to see the men wandering over the county on foot, with the weeping women and children scrambling over the fallen ruins after them. There is no one who can give any correct statement as to the killed and wounded. The country is so blockaded with fallen timber it is impossible to get anywhere, only on foot.*

The Levy County Board of Commissioners was stirred into action by the relief group on October 14. Meeting at the volunteers' request, the elected officials prepared "an official statement of facts and suggestions touching the effects of the terrible storm that swept across Levy County, beginning at

Cedar Keys and embracing an area of twenty by forty miles." The statement went on:

> *More than twenty lives were lost and a great many received serious injuries. The homes of one-half of the people were demolished and the remainder were more or less wrecked. On the coast, a great many islands were submerged and it was there that most of the lives were lost. The boats and tents of the fishermen, together with their homes and household goods, were destroyed. The people of Cedar Keys suffered great loss by the wind, tidal waves, and fire, and many were rendered destitute.*
>
> *In the country, in addition to the destitution of the homes of the people, the ungathered crops were nearly a total loss, and a great deal of the cotton that had been picked and housed was blown away by the storm. More than 75 per cent of the lumber was blown down, and with it the fences which were greatly damaged by the falling timbers. All of the roads are blocked. Many families lost their household goods…and are camping in the open air where their homes once stood.*

Even as relief groups were organizing, the cries for help continued. From the Fort Fanning area on the Suwannee River came a newspaper report: "Many families are now utterly destitute. Some are subsisting on boiled potatoes, cooked in an old camp kettle. The potatoes themselves would have been gone, but for the fact that they were in the ground." And another Fanning Springs report: "I cut my way through thirty-five miles of fallen timber in trying to get to the Suwannee River after the storm." J.M. Dell, a Gainesville relief committee member, reported in mid-October that he had distributed food in Yular among 130 families, 80 of whom were without homes. Most of them were camping around the wrecks of their log houses and subsisting on what scant food they had on hand. The storm had made landfall as women were making breakfast. When the wind knocked over their houses, lighted stoves started fires that destroyed many homes, Dell said. He claimed that it was no exaggeration to say that "999 out of 1,000 trees are down."

A Gainesville man identified as Major Cullen traveled eighteen miles to Townsend's Ferry on the Suwannee River, a trip on horseback that he claimed took fifteen hours. He reported upon his return that the "scene cannot be described. He says hundreds are without shelter and food, and many farms in that country are ruined."

The Suwannee Canal Company's Camp Cornelia and the Brooks Bros.' Toledo had hundreds of persons employed in turpentine and

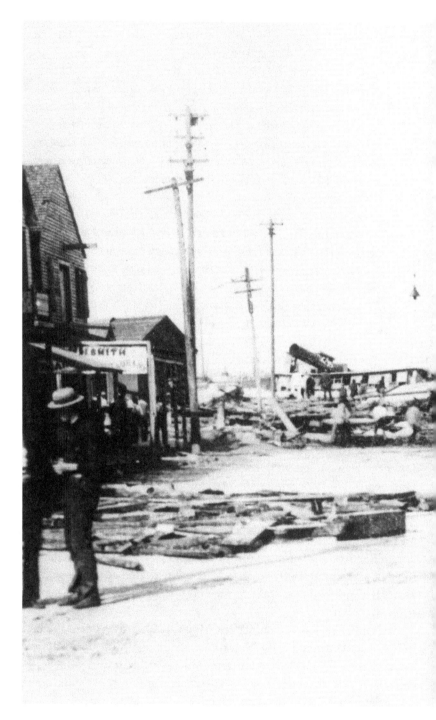

A Fernandina street was clogged with hurricane debris. *State Archives of Florida.*

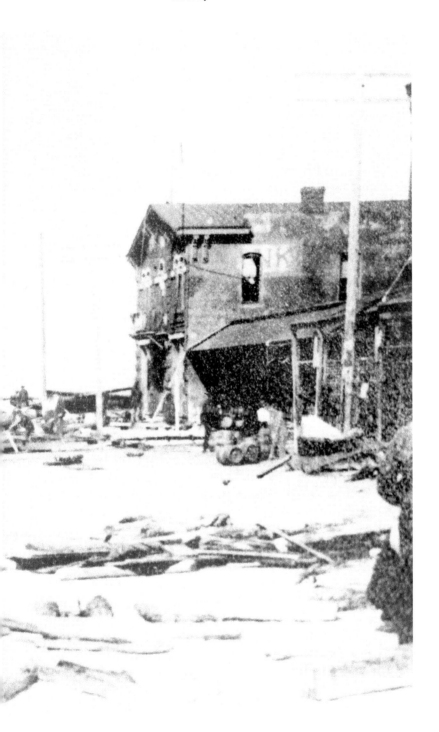

sawmill work, and their safety was of concern to relatives throughout the region.

Gainesville itself was damaged by "a heavy wind storm," according to a special report on September 30 in the *Florida Daily Citizen*. After listing damages—a railroad warehouse, sawmill and church—the correspondent added, "The storm in this city and the loss thereby pales into insignificance when compared with the loss in other places near here." And, after describing losses in High Springs and other communities, the reporter seemed to gasp, "Never in the history of the State has such a storm been known." The *Times-Union*, writing about Old Town, Florida, on October 4, said, "The storm last Tuesday was the worst ever seen in this section."

In fact, the *Citizen* reported, the Jacksonville Weather Bureau observer, identified only as Mitchell, announced that the storm

> *had some peculiarities that have not been seen in the few heavy blows of the kind that have been experienced in this state. Usually they have spread over a large and wide area, but from reports that were gathered during the day* [September 29], *the ravages this time do not seem to have been severe along the east coast...The path of the greatest severity of the storm seems to have been not more than forty miles wide.*

Jacksonville had no communication during the day from Fernandina or Callahan, "or any other point north." The newspaper added, "A large force of men was sent out by the Western Union Company and the work of repairing the damage was begun." That contingent consisted of "regular linemen and twenty extra men." The only working line, the story noted, was to Punta Rassa, "one of the most important wires entering the city, as all of the Cuban business passes over it."

Jacksonville, in 1896 the largest community in Florida's northeastern section, was raked with "the remarkable and unprecedented record [wind velocity] of nearly 100 miles an hour," the *Florida Daily Citizen* reported on September 30, quoting the "Government Weather Bureau in this city." The story continued: "This terrific gale fortunately lasted only about a minute, but for five minutes of which it was a part, the velocity was shown to be rather more than seventy miles an hour. This was about 9 o'clock [Wednesday morning]." The bureau recorded wind speeds of forty-nine miles an hour between 8:00 and 9:00 a.m., sixty-three between 9:00 and 10:00 a.m. and thirty-six at 11:00 a.m.

Water, Wind and Fire

A Plant System train engineer arriving in Jacksonville on a run from Savannah reported a death in Folkstone and the Uptonville railroad station leveled in Georgia.

Under the subheadline "Cut Off from the World," the *Citizen* reported:

> *The wires were reported down at many places between Ocala and Baldwin and west of Baldwin on the Florida Central & Peninsula Railroad. Between Callahan and Waycross, along the Plant System, twelve miles of poles and wires went down in a tangled mass. A similar state of things prevailed on the line of the Florida Central & Peninsula northward from Jacksonville toward Savannah. In short, Jacksonville last night* [September 29] *was completely isolated from the North; not a single telegraph wire leading from this city out of the State being in working order.*

Wind damage and lowland flooding occurred in Tampa. The *Tribune* listed among the losses a new bridge across Spanishtown Creek washed off its foundation and beachfront walls eroded by high tide. Flooding missed another fringe community. Micanopy, north of Levy County, reported "very little rain" but wind damage to fences, window glass and trees and "horse stock" killed.

Having lost their property fences was not a minor matter for farmers with livestock out to pasture. No doubt frightened and disoriented, the animals would be wandering in search of clearings for food and shelter, thus causing their owners new problems in finding and bringing them to home property safely.

CHAPTER 6

HURRICANE 4 HEADS NORTH[48]

It was one of the worst storms on record in the District of Columbia.
—*Jay Barnes*, Florida's Hurricane History

Captain Tawes and his crew, while anchored on the tidal St. Mary's River in Florida's northeast corner, did not experience the surge, but the wind caught their merchant vessel. Tawes had no way of knowing that weather observer Marbury was logging what Tawes felt: "The progress for the following twelve hours was slow, for on the morning of the 29th it had advanced only as far as the southeastern portion of Georgia." Writing in the way of old sailors, Tawes referred to his ship interchangeably as "me" and "her" and spelled hurricane with a *y*. He wrote:

> *While there, we had a dreadful hurrycane. It tore me from my mooring and carried me across the river* [to the Georgia side]. *The* Harold B. Cousens, *a Boston schooner, broke from her moorings and came across the river. He hit my vessel and broke a plank in her stern. When I had crossed the river, my first duty was to secure the ship before the next shift of wind. That would have blown us down the river or across from where we came and would probably do lots of damage. As quickly as we could we got a new five-inch hawser on shore and began tying it to the trees. And as fast as my men would get it tied to these large pines they would blow down. But we got the lines out to the bodies of a dozen trees and to some of the few that stood.*

That rope five inches thick was what saved the *City of Baltimore* from breaking free and crashing into other vessels at the Kings Ferry landing. Tawes's ship would have been a huge projectile. It was 138 feet long and had a net weight exceeding 675,000 pounds.[49] On Cedar Key, a smaller vessel, but nevertheless a craft with great weight, had been tossed out of the harbor and onto the community's main street.

THE CEDAR KEYS HURRICANE OF 1896

On the Florida side of Kings Ferry, Captain Leonard Tawes had help from young stevedores who lived nearby. Tying his *City of Baltimore* securely had saved it from damage. This was not so for others. The *New York Times* reported on October 2: "Two schooners unloading lumber at Kings Ferry were blown from their moorings and landed in a maroon, three of the sailors being killed." The term *maroon* was being used to describe an inaccessible place, probably marshes within heavy woodland. Upstream on the St. Mary's River, several boats were stranded that Tuesday. The stevedores who helped Tawes "went home to change their clothes [and found] their homes were flat on the ground. I wish I were able to describe the damage this hurricane did around Kings Ferry." In fact, the captain detailed some of the scene as he tried to help a Florida family. Tawes wrote:

> *I do not think I ever beheld such wreckage. The house had been blown about sixty or seventy feet. I could not believe there was so much in a house: crockery, tinware, cooking utensils, lamps, and straw mattresses all strewed along on the ground from where the house started to where it stopped and fell to pieces.* [With an ax, Tawes cut a hole] *through the roof, which was now flat on the ground. In a short time I found him and he was dead. He had a bruised place on his back and he smelt so much like fever. They said his fever had broken that day and he was getting better. He was eighteen years old.*

The Mozelle sawmill owner, Tawes wrote, "gave [those] living at Kings Ferry the lumber free to build their homes again." The Florida business itself "had lost $12,000 [2009, $540,000] worth of timber. They had certain acreage in fine timber that no ax had ever been in [and] which they were holding in reserve." The timber could not be salvaged, Tawes was told, because it "would be full of bug holes and become unsalable before he could get it out."

The captain was further impressed with the Mozelle loss. When his vessel was being towed downriver to Fernandina after taking on the Curaçao load, he wrote, "my eyes never beheld such wreckage. Trees were blown down in piles, some with their tops blown off."

By the time Tawes had visited the ship chandler in the coastal city, purchased stores, cleared customs and set out to sea, the date was October 8. He spent the October 10–11 weekend in "another hurrycane," this one traveling north along Florida's east coast. He arrived safely in Curaçao after, as he put it, "worrying with the different kinds of weather, good, bad, and indifferent, for twenty-two days."

Hurricane 4 Heads North

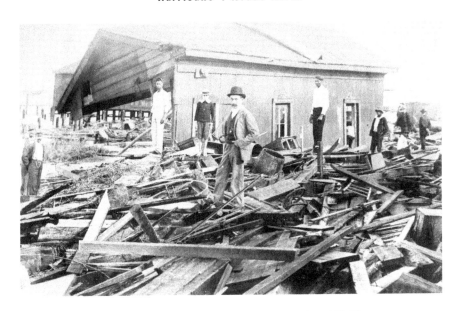

Fernandina buildings were ruined in the 1896 storm. *State Archives of Florida.*

Fernandina, in the meantime, counted its greatest damage in fallen oak trees and signs and building blinds downed by the winds. Great differences in storm conditions also were reported in St. Augustine, which "was visited by a severe windstorm, accompanied by rain," while Sanford reported "only squalls," according to *Citizen* accounts on September 30.

The winds of Hurricane 4 flashed around Florida's Atlantic coast before quickly heading north to ravage Brunswick, Savannah, the Sea Islands and dozens of small, inland Georgia communities on the way into the Carolinas. As the hurricane's outer force veered almost to the eastern coast while ripping through Georgia, men on the sea could attest to the weather observer's report that the storm's "progress during the 29th was materially increased, its center reaching the interior of North Carolina by 8 o'clock p.m." During the preceding twenty-four hours—that is, since turning directly for the landfall at Cedar Key—Number 4 had increased in severity as it moved up the coast. The observer pointed to "the rapid decrease in the air pressure and increased wind velocities."

But soon the entire nation would be in the dark, literally, for news about Hurricane 4. Marbury reported:

> *Telegraphic communication has been so interrupted that no reports have been received from stations in the east or southeast. Therefore it is impossible*

to trace [the storm's] *exact course and progress after 8 o'clock p.m. September 29ᵗʰ.*

Now the only way to know where the hurricane was spreading violence was to be part of it. Like a rollercoaster going up and down, the storm's speed and pressure seemed to abate sharply and then return at new levels of fury as it headed up the eastern coast toward the major population areas.

In twenty-four hours, Hurricane 4 was to race from Cedar Key to the Great Lakes, a distance exceeding 1,100 miles, at an average speed of 46 miles per hour. An October 1 *Atlanta Constitution* headline neatly summed up the storm's path north of Cedar Keys: "Hurricane Spreads to East and Northwest and Continues Damage; Florida, Georgia, South Carolina, Virginia, District of Columbia, Maryland, and Pennsylvania Suffer Severe Losses from the Terrific Gales—The White House Is Not Passed and Cleveland's Country Home Is Unroofed."

Jacksonville

Between Jacksonville and Waycross, Georgia, the *Constitution* reported,

the once fine timber forests that skirted the [railroad]*...were leveled by the wind and present a prairie-like appearance. As far as the eye can see on either side of the railroad the timber is ruined and the ground is literally strewn with logs and debris. Homes are in ruin and household effects are scattered around the place. Many families are sitting on the ruins of their houses, lamenting their misfortunes. Children cling to their mothers and weep because they are homeless and hungry. The spectacle is at once pathetic and terrible.*

In Boulogne, Nassau County, north of Jacksonville, five were killed. The Atlanta newspaper wrote: "When the school building collapsed, there was a panic, two pupils, Miss Johnson and young Stewart, were killed, and several others sustained serious injuries." The school apparently splintered and "flying timbers did deadly work. An infant in its mother's arms was struck by a piece of timber and instantly killed." In addition, twelve-year-old Lilla Raines escaped the school and, with Harry Johnson, made it to her home, only to die there with her mother and Johnson as that building collapsed. At Hilliard, four were killed in another school's wreckage. Kings Ferry counted six dead, including three sailors.

Hurricane 4 Heads North

Georgia

Passing over Florida's northeast corner into Georgia, Number 4 brought major damage first to coastal areas. Datelined Savannah, a shared news story began, "The Sea Islands along the shores of Georgia and South Carolina had almost a repetition of the storm of 1893. Almost every cabin and cottage in the wake of the storm was destroyed." Fatalities, the story said, "are not expected to go over 100," and "only those who happened to be caught out in boats were drowned." The October 1 *Constitution* covered news from St. Simon's island:

> The tin roof of the hotel is gone, all the bathhouses, tenpin alley, and [many] cottages are blown down...All the churches, except that at Frederica, reported wrecked and partially damaged. The south end of the Negro village suffered severely. The ocean pier is completely destroyed.

In rural Georgia, Camden County listed six residents killed, and Charlton County lost four children, all at school. The newspapers also listed seven dead in LaCrosse, including four at a turpentine farm, three in Newberry and five in High Springs, two of whom were fatally injured when the wind knocked over a boxcar in which they had taken shelter. The heavy car was carried fifty feet. A Brady woman was killed, but "a babe at her breast was unhurt, although it had been carried some distance by the force of the wind." Bradford County in Georgia listed four dead. One of the latter was reportedly a man standing nearly a half mile from two cars loaded with bricks that were "blown to pieces."

The *Constitution* was to report on October 7 the strange storm pattern and its effects in the area of the Santafee River. On the north side, "the storm was far more violent and ten times more destructive than on the south side...In a neighborhood ten miles square, settled well, there are but four houses not blown down or unroofed or crushed by falling trees."

Brunswick, south of Savannah, also suffered greatly. A major loss, both financially and sentimentally, came with the collapse of the city's opera house. Flat on the ground, "one of the most beautiful buildings" in the city was depicted in the *Atlanta Journal* by an artist. Other sketches showed the damage to D'Arioso Hall, a Monk Street restaurant and one of at least six churches that were struck. The caption beneath another drawing read, "High and dry—stranded vessels." The *Constitution* told also of vessels damaged in the bay, including the "seven-ton sloop *Katie Sharp*, its owner from Chester, Florida, terrapin fishing; and the schooner *Henry Crosby*,

carrying three hundred tons of coal, scuttled after being blown into a marsh and leaking badly." Among the larger vessels damaged when blown out of the water were the Spanish bark *Encarnacion*, the Spanish brig *Anton*, the Norwegian bark *Longfellow*, the bark *H.L. Routh*, the brig *Jennie Hulbert* and the schooner *Sara Fuller*, all loaded with cargo. Six vessels anchored in the sound weathered the storm. Two American schooners, the *Greenleaf Johnson* and the *Hugh Kelly*, were blown behind the lumber docks while being loaded. The steamer *Hessie*, "with passengers aboard…managed to reach back river and save freight and lives in [Captain Ander's] care." The pilot boats *Gracie* and *Pride* went aground. The *Pope Catlin* "lost its hurricane deck" and, with several other small vessels, was "blown down on the marsh."

H.N. Merrill, associated with the Atlanta Telephone Exchange, was the only rail passenger who made an evening trip from Brunswick to Atlanta. All other passengers left to seek safety at home. Indicative of how news was being passed on, almost like hearsay, the September 30 *Constitution* quoted Merrill as reporting "the famous old gunboat, *The Monitor*, was blown away from her pier and was floating helplessly." This could not have been the famous ironclad of that name. The original *Monitor*, when not yet a year old, had foundered during a heavy storm and sank on December 31, 1862, in the Atlantic Ocean off Cape Hatteras, North Carolina. Sixteen of sixty-two crewmen were lost in the 1862 storm.

Merrill described Brunswick:

> *The streets were filled with debris, wires, telephone and telegraph poles, and parts of buildings blown down and carried away. People were injured by flying objects, and one lady was killed at Everett, a small station a few miles from Brunswick. The railroad tracks were obstructed by trees and poles, and the only train which came through from Brunswick was preceded by a wrecking train and crew for a distance of twenty miles, the crew clearing the track of debris and trees.*

In Brunswick harbor "he saw the masts of three sunken ships…blown away from their moorings and sunk by the great waves of the sea." One of them apparently was the "dynamite boat *Haraldo* [*Harold* in another account], sunk with 5,000 pounds dynamite." The *Constitution* reported also that "the American schooners, the *Greenleaf Johnson* and *Hugh Kelly*," taking on cargo at the Altamaha Lumber Mills near Brunswick, "were blown behind the lumber docks. The eastern warehouse at the new docks of the Southern railway is demolished and about 100 railroad cars are unroofed."

Brunswick's courthouse was preparing to hear

> *the Dauntless case…when the courthouse began to creak and a mad rush was made for safety. Refuge was sought by all in the city hall, a massive structure…The court and spectators had hardly left the room when side windows were crashed in and the floor flooded.*

Brunswick's "immense firebell tower turned completely around [and] in responding to an alarm of fire the hook and ladder truck was blown over while running." The account told of a man identified only as "Jefferson" who "grabbed his baby and rushed toward his door when the house fell in and killed them both."

The *Constitution* had the storm reaching Savannah at 11:00 a.m. on September 29, three hours after raging through Jacksonville. Within thirty minutes, Savannah streets

> *were filled with wreckage; hardly a house in the city escaped without more or less damage…When the wind reached a velocity of sixty-six miles an hour, the instruments at the weather station were blown away. The storm was terrific in its intensity, exceeding that of the great cyclone of 1893.*

Savannah suffered "nine lives lost and a million dollars worth of property destroyed."

Perhaps the most dramatic reportage of the entire storm came in the *Atlanta Journal*'s account of Savannah's experience under the headline "How the Hurricane Swept Savannah and Laid It Waste":

> *Yesterday morning for an hour, the people of Savannah lived and died. Never in the history of the city was there such widespread excitement. Even during the hour of the storm's most terrific sweep hundreds of people, many of them wives and mothers, braved the falling trees and timbers and the gigantic force of the wind, and rushed to the streets in a frantic effort to find kindred and loved ones. It was a stampede—a panic.*
>
> *At 9:30 o'clock in the morning though the sky was darkened and the breezes chilly there was no sign of an approaching hurricane. It came up suddenly. At 10 o'clock, the wind began to blow at a great force and the rain poured down in torrents. At 11 o'clock the storm was on in all of its fury and in two hours the city was a mass of wreckage and ruin…[Delivery wagon] horses were killed and a number of wagons smashed. One driver was caught beneath a falling telegraph pole and killed instantly.*

The story went on to list the many public buildings damaged and destroyed. In Savannah-area waters, the storm created chaos. The Savannah Line steamship *Nacoochee* remained tied to a pier "well up the Savannah River" on Tuesday morning, while "three-fourths of the crafts in the harbor were torn from their moorings and were tossed helplessly about. A Norwegian bark, the *Rosensius*, was capsized and sank, one of her men being lost," the *Constitution* reported. The *Times-Union*, on October 8, reported that the Norwegian ship was to be righted. Two other Norwegian barks, the *H.D. Metcalf* and the *Cuba*, both ashore in the Savannah River, were refloated and were being prepared for reloading.

Columns and columns of the Atlanta daily newspapers were filled over the next week with reports of damage, street by street and sometimes building by building. Drawings by newspaper artists illustrated the destruction.

South Carolina

Hurricane 4 winds reached a speed of sixty-two miles per hour during its 12:00 to 2:00 p.m. flight through Charleston on September 29. "Trees, fences, gutters, and loose signs came down, and umbrellas and hats went up," a creative *Constitution* writer reported. Hundreds of people watched waves crash over sea walls in the bay and reach ground depths of three to four feet deep. "The bay was a grand sight," the Atlanta writer cooed. But by 5:00, Charleston was "absolutely cut off from the world. Not a wire was working in any direction." Nevertheless, the city suffered no loss of life or serious damage.

The storm was more damaging elsewhere in South Carolina. "The storm did not touch Columbia," the newspaper reported, "but fifty miles below and above houses were blown down." A Hardeesville lawyer, traveling on the Port Royal & Augusta Railroad, told fellow passengers that he feared for his family.

> *He arrived home to find his newly erected house torn from its foundations. His family, however, had escaped, having been warned by the falling of the chimney, which was followed by the building taking fire. Seven Negroes were killed at Hardeesville by the wrecking of their cabins, and the station of the Savannah, Florida & Western Railroad was blown down. Near Yemassee Junction [a passenger] saw a station uplifted and bowled along half a mile by the hurricane, while the drawbridge over the Savannah River five miles above Hardeeville was lifted off its supports.*

A passenger headed into Savannah from Baltimore on that railroad line reported "seven times in one hour passengers were called upon to get out and help remove obstructions from the tracks."

The Number 4 hurricane of 1896 has also been blamed for deaths on the high seas. Charles A. Burroughs, mate of the schooner *Charlotte T. Sibley*, told the *Atlanta Journal* on October 12 of the ship's problems off the Charleston coast on the night of September 29 as Hurricane 4 raced northward. "Huge waves washed the deck and carried away a part of the deck load," 300,000 feet of dry boards from southern mills headed for New York. "The remaining boards swelled and burst the sides of the vessel open just below the rail. All hands were put to work on the three pumps and for eighteen hours they continued to pump." Strong winds carried away the rest of the deck load and the fore and main rafts. "The men were kept at the pumps constantly night and day, and after hard work the vessel landed in New York twelve days after leaving the bar." The vessel was towed to Belfast, Maine, for repairs.

North Carolina, Virginia and Maryland

Author Jay Barnes has noted that the hurricane's "severity lessened through the Carolinas. But once it reached Virginia at about 9:00 p.m. on Wednesday, September 29, it apparently increased in intensity until it passed through Pennsylvania at midnight."

In Staunton, Virginia, a lake dam at the fairgrounds burst, sending Lewis Creek into flood stage. The high water roared through the city, taking bridges, destroying "a vast deal of property" in the business section and causing the loss of several lives, the *Constitution* recorded. "About forty horses and mules were drowned, and the bodies of five Negroes have been recovered. Other persons are missing. The gas works are destroyed." A creek at Waynesboro, Virginia, rose fifteen feet "and wrenched buildings from their foundations… Reports from all surrounding country [indicate] great loss to the farmers."

Maryland reported six deaths, "most of them near Baltimore." An early report from Baltimore noted that

> high winds forced the water in the harbor up into the bed of the streets and almost the entire northern waterfront is submerged. Several schooners that were tied up at Pratt Street wharf broke from their moorings and are resting in the middle of the Pratt Stream. The lower floors and the cellars of warehouses are flooded.

District of Columbia

Barnes described Number 4's visit to the nation's capital as "one of the worst storms on record in the District of Columbia." The *Atlanta Journal* began its report on October 1:

> *An equinoxial storm last night gave Washington the worst shaking up it ever had. The wind blew in a rotary, twisting, wrenching velocity of 75 miles an hour. Rain was driven in floods—it did not fall. Lightning pierced and lit up the tossing black clouds and sharp claps of thunder contributed to make nature a weird caldron.*

"Washington Not Spared" read the main headline over the October 1 story in the *Atlanta Constitution*. A subhead added: "Four deaths and many instances of serious injuries; farms are devastated; collapse of schoolhouse kills two."

Twenty hours after making landfall at Cedar Key, Number 4 had "struck Washington between 11 p.m. and midnight" on September 29. Although reduced to a category 1 hurricane, the storm "ripped off some of the coping of the white house," the newspaper reported, not giving the president's residence capital letters. As well, the storm "laid low most of the historic trees in the white house grounds, including the elm tree which Lincoln planted." The story continued:

> *It carried away part of the roof of the state department, where the official documents are stored, but fortunately left the records unharmed. The costly roof of the patent office, constructed after the fire there some years ago, was picked up and distributed all around the neighborhood and skylights half an inch thick were remorselessly beaten in. The naval observatory and, in fact, pretty nearly every other public building, was more or less damaged. Churches and theaters suffered alike. The roof of the Church of the Covenant, where President Harrison used to worship, was blown down and each square plate by a curious freak planted itself upright in the grass parking [lot] which surrounds the edifice.*
>
> *Still more disastrous was the fate of the New York Avenue Presbyterian Church, which Bryan recently attended, sitting in Lincoln's pew. The whole tower of the edifice was reduced to match wood and persons in search of souvenirs had no difficulty in obtaining them...The total destruction of property in Washington City by the storm is estimated at nearly half a million dollars [2009, $21 million].*

Hurricane 4 Heads North

National cemeteries in the District of Columbia area suffered major damage.

The sexton at Arlington National Cemetery reports that the trunks of fallen trees lie across the tombs, all over the grounds. The Soldiers' Monument was not damaged but there are hundreds of mounts which must be rebuilt and again sodded.

Perhaps the worst cemetery damage occurred at the Soldiers Home. Among three hundred fallen trees were thirty "beautiful trees, most of them oaks which have withstood the storms of more than fifty years." The administrator estimated that three years would be needed to clean up the rubbish. The newspapers also reported, "In some instances in the cemeteries, the upturned roots of the trees brought with them portions of caskets and their contents." Uprooted in Oak Hill Cemetery were two trees erected in memory of John Howard Payne, the composer of "Home, Sweet Home."

A newly constructed five-story building at 1213 Pennsylvania Avenue collapsed, "crushing Beatty's restaurant and Kelly's dairy lunch adjoining, and imprisoned six men," said the *Journal*.

Pennsylvania

Number 4 was still strong when it advanced into Pennsylvania. The *Constitution* wrote on September 30: "Severe floods are reported along the southern border of the state, and between Cumberland, Maryland, and Grafton, West Virginia, where bridges are reported to have been washed away." The Baltimore & Ohio bridge at Everett, Pennsylvania, was washed away. "All mountain streams are raging torrents," the newspaper wrote. "Their narrow passes are choking the floods."

A report from Philadelphia on September 30 began, "Last night's storm did great damage in this state, but the wires are down in nearly every direction and it is difficult to obtain reliable information."

North of Reading, "the cast house of the temple furnace at Temple station was blown down by the wind and nearly a dozen workmen were buried in the ruins. The men were pinned down by the heavy timbers" and two of them were killed.

Everywhere the storm raged, communication lines were down. One newspaper story said, "The storm which swept across Florida, southwest Georgia, and South Carolina destroyed the telephone and telegraph wires…and Atlanta and all intermediate points were cut off from Savannah,

Jacksonville, and Charleston." A story datelined Pittsburgh noted, "In the absence of telegraphic communication [east of here] it is almost impossible to obtain any information."

New York

The *Auburn Daily Advertiser* reported the storm on September 30, detailing the wind and damage to area trees, especially those bearing fruit. The article stated, "The weather was pregnant with storm all day…Orchards have been robbed by the wind."[50]

Great Lakes

Winds whipped up the ocean-like Great Lakes as September's last hours faded into October. The *Atlanta Journal* quoted the Chicago Weather Bureau's Professor Garriott as saying:

> *The western storm has moved west of north, and is central this morning over northern Lake Huron, where the barometer, reduced to sea level, stands at about 29.32 inches. The westward movement of the storm has been attended with destructive easterly gales.*

A story from Chicago reported "great damage to property and many accidents…from the furious gale on the lakes." At Chicago, the schooner *Seaman* broke from moorings in Slip E and "while being hurled about by the storm wrecked and sunk half a dozen smaller craft." The story listed five "yatchs," two houseboats and four small fishing boats "sent to the bottom by the runaway schooner."

On October 3, the *Jacksonville Times-Union* carried a report entitled "Hurricanes Come in Pairs." The anonymous writer was correct in predicting another storm by October 14. On October 10, a new hurricane swept up the Atlantic coast. The Gulf communities were unharmed, but the new storm, Number 5 in 1896, caused heavy damage in some of the Florida- and Georgia-area communities that had been hammered by Number 4. Unlike the surprise Number 4, the Weather Bureau sent warnings a day ahead about the newest storm. The *Times* reported on October 11 that the storm was blowing off the coast of North Carolina and was headed for New York. Mariners as far north as Massachusetts had been alerted.

RELIEF

They deserve help. They must have it or starve.
—D.G. Ambler, Jacksonville Storm Relief Association

Almost within hours of the Number 4 hurricane's passing out of Florida, it seems, help was on its way to struggling survivors. Storm Relief Associations were formed in many communities to assist places like the Cedar Keys that had been the hardest hit.

The head of the Jacksonville association's soliciting committee implored the general public:

> *No one who has not been over the path of the storm can conceive any idea of the disaster, nor of the pitiful condition of the people in that section whose homes, crops, barns, livestock, and occupation have been swept away in a day.*

D.G. Ambler told the *Times-Union*, "There are thousands of such people." And the newspaper editorialist added that "Jacksonville, the wealthiest and most populous community in Florida, should be the first to come forward."

Almost as quickly came the cries for help. Petitions were drawn and delivered, one way or another, to county commissioners and other authorities, as well as to the relief groups. Cedar Keys was not the first to ask for help. The appeal did not go out until Sunday, October 4. The delay can be ascribed only to the stunning blows that the community had suffered and the need for time to collect its wits. The *Jacksonville Times-Union* headlined the news: "Cedar Key Utters A Cry; She Is Sorely Stricken; Burden More Than She Can Bear." Gathered at the Christ Episcopal Church, some of the town's leaders were appointed "to take such action as necessary to place our condition before the world," the *Atlanta Constitution* reported on October 7. Named to the committee, which elected its officers the next day, were G.W. Moyers, chairman; W.H. Anderson, secretary; and F.E. Hale, W.D.

Finlayson, J.B. Lutterloh, R.M. Dozier, W.H. White, G.M. Sistrunk and R. T. Walker. The nine members, all men, prepared a statement that asked assistance from "the citizens of our common country...Cedar Keys is forced to ask that charity which she has always so freely given."

"Bronson Comes to the Front" was the headline of the October 10 *Times-Union*. A "mass meeting" on October 1 had formed a committee under Colonel John F. Jackson to assess needs, to collect donations of money and supplies and to distribute them to the needy. Percy M. Colson, clerk of the circuit court in Levy County, volunteered to visit the stricken areas and report with a list of needs. The committee said that "at least 50 per cent of the families are now homeless" and noted the loss of the harvested cotton crop, "blown away with the houses which contained it...No people ever stood in greater need of the timely aid of a generous public."

Colson's dismal report, as outlined in the newspaper, read:

> *The picture of desolation could not be overdrawn, that nearly every house was either blown down or badly wrecked, that stoves, sewing machines, dishes, and chairs were smashed, and that the people had nothing to resume housekeeping on. In nearly every home, one or more members of the family are more or less seriously injured. Business is paralyzed and the people are demoralized, and each is unable to assist the other.*

The Bronson group had generous leaders. On the first report of donors, Colonel Jackson was listed as giving $25 and Colson, $10 (2009, $1,050 and $420, respectively). All donations were not cash; Mrs. S.P. Turner gave one set of furniture and three bedsteads and S.H. Highsmith offered the use of one team.

The county commissioners cited the need for "cash to buy lumber and shingles and to employ labor" and added its acknowledgement of contributions from Jacksonville, $300; Governor H.L. Mitchell's contingent fund, $200; and Tallahassee citizens, $100.

Help was also coming "from far away," a newspaper headline reported. James M. Tucker, who claimed to have "weathered a summer of [storms] right there at Cedar Key," sent five dollars from his home in Cumberland, Maryland.

The Cedar Keys committee also reviewed the frightful losses that the community had suffered and outlined its goals:

> *We have to feed the hungry, clothe the naked, and provide shelter for the homeless, and we desire to provide means by which the destitute people can*

be put in the way of making a living. Our churches and schoolhouses are destroyed, almost every business house more or less damaged, while many residences are destroyed and others damaged. The surviving dwellers on the small islands of the adjacent coast, where many lives have been lost, and every house destroyed, will have no other source to look for help than to Cedar Keys, and aid must be given them. With these appalling facts before us...we ask that [donors] respond promptly to the call. Of the press, we ask that it give publicity to our needs.

The *Times-Union* was ahead of the Cedar Keys request. An October 7 editorial began

The storm of last week cut a swath through the state from Cedar Key to a point near Fernandina, and left desolation and destruction in its wake. Already enough is known to establish the certainty that immediate relief is necessary...The good people of Jacksonville have made a start which should be continued until no further necessity for aid exists. Today [we publish] a list of the substantial contributions made, and will continue to do so, giving credit to the donor unless he desires otherwise.

The Jacksonville relief group also was ahead of the Cedar Keys petition. On October 8, the secretary sent word to county commissioners of Levy, Baker, Lafayette and Columbia "that their drafts for $300 each would be honored by the Storm Relief Association." The Cedar Keys and Bronson petitions went before the Jacksonville association on October 10. The islands' Anderson and Bronson's Jackson were notified that the Levy County commissioners were "authorized to draw on the association for supplies and if the commissioners will delegate authority to any committee and so notify the association the draft of such committee will be honored and supplies will be sent."

Jacksonville's committee was moving quickly. A fund raised in the 1880s to help with a yellow fever epidemic was tapped for $10,000, which the storm relief committee began distributing on October 5. The Sanitary Auxiliary Association, which handled the epidemic funds, voted an additional $5,000 on October 12. That brought the amount on hand to $7,000 (2009, $294,000).

The relief group, sparkplugged by the active D.G. Ambler, soon found it necessary to form several committees to carry out the separate functions of raising funds, reviewing appeals and distributing relief donations. The disease fund gift, the equivalent in 2009 dollars of nearly one-half million,

started a chain reaction. The Clyde Steamship Line pledged $100 (2009, $4,200), and Henry M. Flagler, the businessman who had championed and funded a railroad south to Key West, sent a telegram to the Jacksonville committee pledging $1,000 (2009, $42,000). "The donation of Mr. Flagler will doubtless cause others to give liberally to aid the sufferers," the newspaper said. Flagler's pledge was listed, along with hundreds of others, during the next few weeks in newspaper columns recording names and amounts.

Jacksonville also seems to have taken a lead in suggesting that the many Florida counties establish a central distribution system, which, in turn, would ship donated supplies, equipment, food and money to the county commissioners for distribution to the communities they served. Until a better system was set up, Jacksonville's early funds and resources were sent to Levy, Baker, Lafayette and Columbia, the counties most in need. Throughout the state, newspapers published lists of donors and, usually, the amount each gave. The first Jacksonville list ran from $0.25 to $25.00. Mayor E.H. Mote and six other Leesburg men sent the *Citizen* editor "New York Exchange for $77.50...to be used to the very best advantage for storm sufferers."

The storm had brought unexpected debt to the brotherhood of the sea. The October 8 *Times-Union* explained:

> *Not a fisherman but lost at least one boat and net, each of which represents a value of from forty to eighty dollars, and as a large majority of these men get their outfit on credit and pay in installments during the fishing season, they will all have to be furnished anew by some method of relief.*

Baker County, "being a large cattle-raising section," could not estimate its loss in beef and dairy animals until spring, an Atlanta newspaper reported. Nevertheless, Baker County commissioners had called on the governor within a week of the storm "to devise some means to assist the suffering people." The *Times-Union*, on October 3, ran the names of scores of injured residents and the sheriff's claim that only twenty to forty of the county's one thousand homes had escaped loss. Apparently caught up in the appeal for help, the writer added, "If something is not done there will be famine right at our doors."

Other counties quickly added their petitions for help from the state, leading to calls for the legislature to convene an extraordinary session and work with Governor Mitchell in authorizing assistance.

Relief

The October 8 *Times-Union* reported:

> *A mass meeting of the citizens of Tallahassee is called to meet in the city hall Thursday night, in the interest of the sufferers from the storm. Every effort will be made to send assistance to the destitute. It is hoped that the attendance will be large. Carrabelle sends forward today a large box of clothing for the storm sufferers at Cedar Key.*

The state capital group acted quickly and within four days had completed a canvass of the city, raising hundreds of dollars. The people of Carrabelle later sent money to Cedar Keys' Anderson.

County commissioners at Macclenny sent a petition for help to the governor, noting that attempts were being made by a local relief committee to coordinate efforts with the relief group in Jacksonville. On the morning of October 7, "public road hands began work…cutting trees from across the roads."

At Newberry, the relief committee appealed for "nails to make shelters. There are not nails to be had in the stores and several parties reported that a great many families [are] camping."

Kings Ferry, where Captain Tawes had managed to save his freighter, joined the communities reaching out to help. An October 14 news report noted:

> *Kings Ferry, though herself a loser by the storm, responds to the call of the relief committee at Cedar Key and sends $15.25 to relieve the destitute. This amount was raised by a collection Sunday night in the Methodist Church.*

Communities on the storm's fringes and beyond found ways to contribute. On October 12 at Ocala, the Metropolitan Band, Metropolitan Orchestra and several musicians and vocalists combined for a benefit concert for "the storm sufferers," the term used almost universally. The *Morning News* editor in Ocala "began a canvass," and the Presbyterian Church Ladies Aid Society joined in. The newspapers' most effective contribution, however, may have been through the stories they published for weeks after the storm. The *Citizen* began an October 10 story as follows:

> *Every day someone arrives in Gainesville and tells fresh stories about the storm. Throughout the western and northern parts of Alachua County, in Lafayette and Bradford Counties, the people are laboring patiently and vigorously pushing the work of rebuilding. Some time must elapse, however, before those who were left homeless can provide themselves with shelter. Today,*

a heavy, steady, cold rain is falling and hundreds of women and children are exposed…A man from Flore, a few miles to the north of Yular, was shedding tears this morning. "My God," he said, "just think of it, you who have shelter and clothing. My whole family, wife and several little children, are in the whole of this heavy rain, and suffering from exposure. They have only a few bedclothes and, of course, they have been soaked. I have done all I could for them, but it makes me cry to think of their suffering like that."

Gainesville residents responded to such pleas. "Box after box of food, clothing, etc., are being shipped," the *Citizen* reported on October 10. "The ladies of Gainesville are still at work. They have purchased a lot of cloth, and are making clothing of every description. In addition to what has been done in Gainesville, appeals have been sent out to all parts of the United States."

Georgian communities, despite their own losses, were quick to begin collections. Albany, Georgia, had formed a relief committee within days and "8,000 pounds of provisions and clothing were on the way." Waycross and Savannah, itself pounded by the Number 4 hurricane, formed committees. Under Mayor Herman Myers, the Savannah group "met with much success," the *Citizen* reported on October 9. "As fast as donated, supplies will be shipped by railroads free of charge." Officials of both the Florida Central & Peninsula Railroad and the Plant System had helped found the relief committee there.

Georgians also seemed especially alert to their needs in the storm's aftermath. Brunswick's "live businessmen," as the *Constitution* called them,

left the night of the storm for Atlanta and returned [October 1] *with dealers in roofing of different descriptions. They have made a complete canvass of the city and it is probable that the days of tin roofs here are numbered, and in future wood, paper, and other materials will be used. At present, there is not a sheet of available tin in Brunswick. All the unroofed houses are in bad condition on this account.*

Another form of relief came in a controversial suggestion from D.G. Ambler, who was heading Jacksonville's solicitors under the Relief Association. Speaking as an officer of the Atlantic Lumber Company in Jacksonville, Ambler told the *Times-Union* on October 9

that he feared a cyclone of fire would ensue this winter or spring in the section swept by the storm last week. He feared that the fallen timber, and all of

the houses adjacent thereto, would be swept by fire. He said that usually the woods were set on fire and great damage was done early in January or February, but this year the damage would be far greater than heretofore if these woods fires were allowed to prevail…Mr. Ambler suggests that it might be well to fire the woods now before there is any considerable quantity of inflammable material on the ground to burn…Mr. Ambler suggests that the country papers call the attention of the people to the danger and advise preventive measures be taken.

Ambler's call for woods fires to be purposely set was picked up by the newspapers. The *Citizen*, on October 10, editorialized:

The woods have not been burned out in years and pine needles are several inches thick upon the ground in some places, to say nothing of the great quantity of them that are on the immense tree tops now lying on the ground. In places where the trees were boxed for turpentine, there are thousands of barrels of crude turpentine still in the boxes or scattered over the ground. The pine trees will be dead in a few months…Old citizens say that if the woods are not burned at once they may catch fire in the spring, when not a dwelling house would be saved.

The United States government, long before bailout became a practice to help depressed industries, announced a major benefit for the southern lumber businesses and certain landowners under a plan that had the potential to both reduce taxes and clear some forest areas of fire danger. In late October, word came from B.F. Hampton, a Gainesville land and mining attorney visiting in Washington, "that all bona fide homesteaders of Government land in the district devastated by the recent storm in Florida may sell the fallen timber on their homesteads without fear of being disturbed by the Internal Department." The story added, "This is a very important one, and will enable many to make another start in life." The news was especially good in the Cedar Keys area. Attorney Hampton wrote:

This will at once start an industry that will give employment to many of the stricken people and enable them partially to rebuild their homes. I am also satisfied that those homesteaders in that section who leased their timber for turpentine purposes contrary to law can have their entries confirmed, provided they have complied with the law in all other respects. Should Cummer [a lumber company] or any of the companies owning a lot of timber in that country decide to utilize it, they would in all probability buy the timber from

the homesteaders. The owners may, however, float it down the Suwannee River and find a market at some of the large sawmills at Cedar Keys.

The Jacksonville relief group continued activities throughout the fall of 1896. Levy County's request for "nails, 'best' flour, b.b. buckets, blankets" and a dozen bedsteads was referred on October 16 to the purchasing committee, and the next day the supplies were on their way to Bronson. Another report, issued on October 23, said that the committee had sent to Bronson for Levy County "12 bedsteads, 36 wooden seat chars, 20 barrels flour, 2 barrels meal, 500 pounds bacon [and] 24 blankets." Similar shipments had gone to other Florida counties.

The Jacksonville committee somehow came up with a huge supply of nails, perhaps the most sought-after staple in the storm's aftermath. More than three hundred kegs were to be sent in October alone. By the end of the month, the association had "adopted the policy of not sending money, simply sending supplies where the most good can be done for the actual relief of the people."

Another form of caution came from the Gainesville Central Relief Committee. Dr. J.H. Post was sent to devastated areas to determine "the true condition of affairs among the people. This was done," the *Florida Daily Citizen* reported, "to guard against being imposed upon and to enable the committee to distribute food, clothing, and other necessaries intelligently." Post said he covered three hundred miles and reported, "The damage to property has been underestimated. Through the center of a strip ten to fifteen miles wide, the destruction is complete, and does not permit of an estimate." He recommended that the committee rely on "agents already appointed, reliable citizens" without need for help.

Slowly, Cedar Keys picked up the pieces. The *New York Times* reported that "The Florida Central & Peninsula tracks along First Street were under water today [October 10] but a big force of men have been employed on them for the last six hours." The *Citizen* proclaimed on October 22, "Cedar Key Is Rejoicing":

Cedar Key has railroad connection with the outside world, the last trestle connecting us with Mainland having been completed [October 15] and the train coming over it in the evening. It will probably be a month longer before the dock, and trestle leading to it, is completed, but this is so much better than for the past month that no one is grumbling. It has been a hard experience all around: passengers, mail and freight have to be lightered four

*miles in all sorts of weather, and the train crew has had either to camp
out at No. 4 or take the same water transportation, varied occasionally by
trying to "coon" the washed out railroad track. The work of restoration
goes slowly on in the town.*

The *C.D. Owens*, wrecked near the Suwannee River on September
29, went back to work between Cedar Key and Branford even while
repairs continued to the smokestacks, pilothouse, upper roof and several
staterooms. The machinery was not damaged, so the steamer resumed
regular service. Branford's turpentine business, however, was at an end. The
Citizen newspaper noted: "All of the turpentine manufacturers in the river
who were in the storm district are preparing to leave and their camps will
probably soon be occupied by crosstie contractors, who will utilize some of
the fallen timber."

By October 28, one month after Hurricane Number 4 made landfall in Cedar
Keys, "trustworthy and judicious persons in nineteen important places in these
[eight stricken] counties have made calculations that can be depended upon as
fairly accurate," the *Florida Daily Citizen* reported. The reports added up to the
loss of twenty-four lives and the destruction of $1,252,875 in property (2009,
$52,500,000). The report for Cedar Keys estimated property loss at $200,000,
and for all other Levy County communities, the losses were at $250,000 (2009,
$8,400,000 and $10,500,000, respectively). In each of the nineteen reports,
the fatalities, in names and numbers, were listed. Of Florida's twenty-four
deaths, nineteen occurred in Cedar Keys. The report gave a list of

*the dead so far as known: Mrs. Chas. W. Doar and three children, Frank
Havens, Henry Havens, Geo. W. Havens, Sam Gause, Hall Branning,
Sam Robinson, Mrs. J.W. Beacham, Dr. J.C. Speer, Sam Register, L. Ezell,
Captain Brooker, Bradshaw Campbell, three spongers, names unknown.
The last four mentioned are colored, the remainder are white persons.*

The other five Florida deaths were listed as follows: LaCrosse, one man;
Fort White, one person; Longville, one man; and Lake City, "a boy and a
woman, both colored."

Newspapers reporting on the Number 4 hurricane were generally erring
on the side of exaggeration in the first days of the storm. One newspaper
published a single headline running to ten banks. The lead headline on the
Atlanta Constitution's front page on October 2 screamed:

THE CEDAR KEYS HURRICANE OF 1896

Seven Hundred Persons Killed by Tuesday's Tidal Wave At Cedar Keys, FLA Eighty Sponging Vessels, With Crews of From Four to Ten, Swallowed Up in the Fearful In-Flow at the Starting Point of the Terrible Hurricane

Dramatic writing prevailed. The *Constitution* began another story:

Cedar Keys is a place of desolation and death...Today, many of the people are corpses, scores of others are injured, and there are but few houses left standing...Many of the corpses were dug out of the mud in which they were buried by the mighty wave that swept over the town Tuesday morning.

The rival Atlanta newspaper, the *Journal*, was more restrained. On October 1, its main front-page headline began: "Only Twenty Lives Lost; First Authentic Reports From Cedar Keys, Florida, Received Today." The story that followed also seems to have attempted to get at the truth: "Every kind of rumor was started as to the extent of the fatalities, and in every case the rumor could be traced to some individual who had no means of authenticating his statements." The *Journal's* headlines, however, turned negative: "The Town Almost a Total Wreck and Will Have To Be Rebuilt From Worthless Ruins" and "The Florida Coast a Complete Wreck and 2,500 Families Are Suffering From the Storm's Fury."

The newspapers stayed with the story for two weeks, gradually cutting back on coverage. A new storm, Number 5, came up the East Coast on October 10, taking attention away from the September hurricane. By October 15, about three weeks after the surge had swamped the Cedar Keys, the major eastern newspapers were covering only their local regions.

Throughout the fall, the dramatic presidential political campaigns of Republican William McKinley and Democrat William Jennings Bryan commanded front-page attention. The main focus was on McKinley's defending the gold standard, while Bryan argued for silver. The term *bimetallists* commonly appeared in the papers. Spain's brutal treatment of Cubans and Filipinos generally appeared on inside pages, but the cries for freedom from natives in both the Caribbean and Pacific islands were being reported in America. The colonies' demands for liberation from the Spanish monarchy appealed to Americans, so they were prepared late the next year, 1897, when the new president, McKinley, and Congress sent the American military into what would later be called the Spanish-American War in 1898.

The benefit of newspapers has always been in their running local news of no consequence outside each paper's circulation area, and sometimes news

not even of consequence inside that area. Jacksonville's *Citizen*, like almost all publications, published "personals" from its readership zone. From Orange Park on October 27, readers learned that

> *summer absentees are coming back. Mayor H.H. Walling and lady arrived on Saturday…Hugh Partridge is sinking an artesian well for Daniel Doan. This will be the fifth well here, and the Park will be abundantly supplied with water of the best quality.*

CEDAR KEY SURVIVES

"…so here it is possible that a paradise almost can be realized."
—Harper's New Monthly Magazine, *1871*

S ome printed histories of the Cedar Keys claim that the Number 4 hurricane in 1896 wiped out island settlements. That is not correct, partly because the main settlement on the Cedar Key island is today robust in its own self-contained way, and partly because it was well past its best years by the time the storm arrived. Much of the timber on the islands, and, for the most part, the nearby mainland, had already been cut before the storm knocked down most of the standing cedar and pine. Atsena Otie, although the second most populous of the islands, never had a large population, and its abandonment came several years after the 1896 storm, not because of the storm but because Faber's mill ran out of cedar timber to stock its pencil factory.

The conclusion that the hurricane and surge did not cause the death of the Cedar Keys is supported in many places. The best evidence, of course, is in the main island that exists in the twenty-first century with about a thousand residents, a school, several churches and a new major industry—hospitality for visitors. A strong example is in the history of the Christ Episcopal Church. By 1895, the parish was in its twenty-seventh year and had already enlarged its church. But there were only ten families remaining. Three of them departed in 1896, not because of religious problems but because, a 1954 church history states, "the cedar mills had exhausted the timber and moved."

All things are relative, as the saying goes. In 1896, there *were* forests, steamer lines and turpentine distilleries. But they were not of the same size as when the region was growing. In 1868, for example, Cedar Keys had seven steamer lines departing for such ports as Galveston, New Orleans and Mobile. By 1896, there were two.

A key question about the Cedar Keys area of Florida is why so few cedar trees are growing there today. An explanation comes from Charles H. Houder,

One of the few remaining cedar trees on Second Street, Cedar Key. *Author's photo.*

deputy executive director of the Suwannee River Water Management District, which manages Atsena Otie, among other area property. He wrote to me of his speculation:

> *As the cedars were cut, they were replaced by species that out-competed or shaded-out most of the cedars that germinated afterward. Oaks, red bays, and other fairly shade-tolerant species may have become established in the understory of the old forest. Then, as typically happens in such instances, the shade-tolerant species take over when provided with space and sunlight. The less shade-tolerant cedars could not get reestablished. Also, most hardwoods like oaks will resprout from the stump or roots when cut. Most conifers, including cedars, will not. This gives the hardwoods a distinct competitive advantage.*

That description brought agreement from Dr. Francis E. Putz, a botanist at the University of Florida and participant in a study[51] of these coastal woodlands. The study estimates the end of the Waccasassa Bay State Preserve, on the mainland near the Cedar Keys, before the year 2400. The abstract reads:

In this study, remotely sensed data and geographic information system models coupled with permanent plot monitoring data were used to track vegetation changes in Waccasassa Bay State Preserve Park for the period of 1973–2003. Then, using logistic models for land-use change based on elevation and two different climate change scenarios, future changes in vegetation cover were predicted. The most dramatic change observed in land-cover during the monitoring period was a 17.5% reduction in coastal forest due to conversion to salt marsh. The land-cover change models estimate that 50% of the forests present in the Preserve in 1973 will disappear between 2108 and 2228 and all of it will be gone by 2273–2393. Lamentably, faunal and floral migration into upland areas on private land adjacent to the Preserve is likely to be impeded by development in the region.

Dr. Putz also contributed to a study[52] that specifically addressed southern red cedar and cabbage palm. The paper concluded:

Populations of the dominant tree species [cabbage palm] *declined more rapidly during 2000–2005 than predicted from linear regressions based on the 1992–2000 data. Dramatic increases in* [red cedar and cabbage palm] *mortality during 2000–2005 compared with 1995–2000 are apparently due to the combined effects of a major drought and ongoing sea-level rise. Additionally, coastal forest stands continued to decline in species richness with increased tidal flooding frequency and decreasing elevation.*

Forestland loss is being addressed by the state and Floridians who care about natural resource preservation and conservation. In early 2009, the dedication of the Withlacoochee Gulf Preserve, just south of the Cedar Keys on the mainland, was celebrated at Yankeetown. The area's facilities include groomed wilderness trails, one of them a handicapped-accessible boardwalk with a view of a natural salt pond, a thirty-foot observation tower, a picnic area, fishing dock and restrooms.

Although a commemorative marker is at the site of the Eagle Pencil Company, there does not appear to be a memorial or gravestone on Cedar Key dedicated to those who died in the 1896 hurricane. The names of those buried at the Atsena Otie and Cedar Key Cemeteries have been catalogued, and neither listing attributes any deaths to the 1896 hurricane.[53] Burial in the early years was not regulated; not until 1914 did Florida require the reporting of deaths to municipal and county authorities. Even today, some residents can echo the lament expressed years ago by Katherine McCumber McElveen. Interviewed by Lindon Lindsey, she said, "I had a brother that

A historic marker at the site of the Eagle Pencil Company, which was destroyed in the 1896 hurricane. *Author's photo.*

Atsena Otie Cemetery has no hurricane victims. *Author's photo.*

died long years ago, named Frankie. He's buried at Cedar Key with our parents; don't know where."[54]

The 1896 storm had an extended life among those who enjoy studying weather conditions. Newspapers come back to it occasionally because of the drama that accompanied the heavy wind and ocean surge. One newspaper published in Newport, Rhode Island, has long had a special interest in the ocean. A United States Naval Base and related offices continue there today. On the thirteenth anniversary of the Cedar Key storm, September 29, 1909, the *Newport Daily News* filled page eight with a report headed "The West India Hurricane":

> *Aside from the fact that they commonly emerge from the region of equatorial rains which lies between the Lesser Antilles and the African coast, little is known regarding the origin of West Indian hurricanes… The following are descriptions of two important hurricanes that have visited the United States:*
>
> *The hurricane of September 26–30, 1896, was first reported from the northwest of Cuba the 26th. By the morning of the 28th, the centre had moved to the Florida coast, with wind southeast at Key West. By the 29th, it had entered southwestern Georgia and was increasing rapidly in intensity. By 9 p.m. of the same date, it was central over Lynchburg, Va., with barometer, 29.80. The storm reached the District of Columbia about three hours later. On the morning of the 30th, the storm centre had moved to lower Michigan, when its course was deflected and it passed to Lake Ontario and the St. Lawrence Valley in a northeasterly direction. Its passage from Key West to Canada occupied 24 hours, showing a uniform rate of progression of 46 miles per hour.[55]*
>
> *The path of its destruction did not extend more than fifty miles in width in any part of its course. The greatest violence was manifested in Florida during the early morning of the 29th. A second period of violence began in Virginia about 3 p.m. and lasted until about midnight in Pennsylvania. Following a lull there was a third renewal of intensity during the early morning hours of the 30th in Cayuga and Cortland counties, N.Y.*
>
> *The Galveston, Texas, hurricane of September 8, 1900, was the severest and most destructive hurricane in the storm annals of the Western Hemisphere.*

Why Cedar Keys and other Gulf communities lost their cedar and other timberland was no mystery to some of the survivors. Nick Wilder, the Columbia City boatswain who had been swept with a friend from the water off Cedar Key halfway to Ocala, explained:

I have written this book [titled Fifty Years Down the Suwannee River] *for the benefit of the younger generation so that they would know of some of the things gone by since the start of the nineteenth century...I believe that if there is pine timber in this country, it will have to be set out and growed and taken care of like a fruit grove. I can't see how this will work, though, for I have set out a dozen little pine, in my lifetime, and I have had not one to live. But, maybe this will make no difference, for I have heard my Father say that you can make out on whatever you have.*

Nick added:

Well, '96 is now gone, and it was a fine year for crops but a bad year for the pine and other groves. I put the pine in the grove class. I have never seen a pine grove with very much undergrowth in it. This is 1921, that I am writing this story, and there is littered logs all over the place that was torn down by the wind and cold in '96. I believe that they would stay solid for a hundred years. They are soaked with oil, and I doubt if weather could rot them in less than a hundred years. The young pine today are different. I doubt if they would outlast a Black Jack Oak, and that is the shortest lived tree that I know of.

Historian Lindon Lindsey notes that the Faber sawmill was restored to operating condition and functioned for several years, a reason for millworkers to continue living there. The mill has been gone nearly a century now, although some of its brick foundation remains at the shore facing Cedar Key.

The turpentine business continued into the 1930s. In a "Search for Yesterday" newspaper column, Sidney Gunnell was able to list about fifteen distilleries, or stills, operating in 1927. He said, "Cheaper substitutes and more profitable woodland management practices than turpentine [farming] meant the end of the industry after more than sixty years of existence in Levy County."

Fishing will always attract residents and visitors. Spongers still dive in the keys, using modern equipment. A new business, Cedar Key Aquaculture Farms, advertises itself as "Home of the 'Cedar Key Sweets'™ Littleneck Clam." With offices on Cedar Key and at Riverview, Florida, the company claims to be "the largest clam farmer in Florida." The company says that it "carefully controls the production from [Cedar Key] hatchery to harvest and beyond." Baby northern hard clams are planted in Cedar Keys water designated for shellfish activity by the Florida Division of Aquaculture.

Lindon J. Lindsey poses with cedar used in making pencils. Slabs six pencils wide and seven inches long were grooved for "lead" and the two halves joined. *Author's photo.*

The farms provide a "consistent year-round supply" grown to market size, harvested as needed and shipped weekly throughout the United States.

In 1989, at the age of ninety-seven, Ellen Tooke decided to relate her experiences, she told an interviewer, because she wanted to "correct the impression that the island was deserted after 1896." As many as thirty-five families continued to live there into the twentieth century. Ellen was ten years old in 1900 when her parents, John William Tooke and Sarah Jane Delaino Tooke, moved to Atsena Otie with their six children: Ellen, Agnes, Esther, Cora, George and John Gideon. Two more, Margaret in 1901 and William in 1903, were to join the family. The Tookes, like several others among the families residing there, had a two-story home. In Ellen Tooke's interview, printed in *Search for Yesterday*, she was to recall:

> *Those sun-filled days on Atsena Otie were the happiest days of my life. Many of the homes had fenced yards and the island children climbed the fences and trees…Everyone kept chickens, and the fertilizer was mixed with sea grass for the gardens. My, the island gardens were lush and plentiful. We had all kinds of vegetables and fruit—peaches, pears, plumbs, guavas—and we all have grapevines. People used to come from Cedar Key for our fresh garden crops. There was a sidewalk from the dock way on down to the cemetery. It was a wide plank walk with the plank ends outlined with beer bottles…We had a big rain water tank at our place, and a big pitcher pump, too. There was a church and school on the island. The preacher came once a month.*
>
> *Boothby and his daddy moved most of the houses off the island on a big barge to Cedar Key. Our house was taken apart for the move, then was reassembled at Cedar Key. I remember one of the two-story houses was moved whole. When the Andrews brothers—Forrest, Ray, George, and Daniel—bought [Atsena Otie] they maintained the dock and kept it in good repair. Grandpa John W. Andrews came to live with Dr. Dan and Cora Andrews. Grandpa had been a farmer from Muncie, Indiana, and Dr. Dan arranged for a boat to and from Atsena Otie for Grandpa to garden every day. He had a regular little farm on the island.*

One of the buildings brought from Atsena Otie houses the *Cedar Key Beacon* office. With a wood frame and metal ceilings, it was relocated in the heart of the village business district on Second Street. A major nineteenth-century building still in active use is the Island Hotel. It stands across Second Street from where it was built in 1859.

The Atsena Otie headstone of Elizabeth Stapleton, who died shortly before the 1896 hurricane. *Author's photo.*

Although change often brings out the sentiment familiar with a loss, change also brings improvement; strength replaces weakness. La Crosse, in Alachua County, had a population of only a few hundred people in 1896. They lost fifteen buildings in the hurricane. LaCrosse continued as an agricultural region, mostly given over to cotton farming. The storm had not deterred survivors. A year later, on December 17, 1897, LaCrosse was incorporated as a town.

A huge new cement wharf stands today, like a formidable sentry, in Cedar Key harbor on Dock Street. The street was so named because a wood dock had occupied that space in the water since the 1800s. Many loads of fill were brought to build the street. Writer Sidney Gunnell offered a sentimental farewell:

> *The old dock had become impractical; it had to go and I saw the logic of that. No more steamboats would ever come down the Suwannee to load there. Its railroad connection vanished over forty years ago. Still, it was a relic, a symbol of the old days. I stood there and watched it being dismantled with a feeling of saying goodbye to something.*

Stilts are common underpinnings for newer buildings along Florida's west coast, including the Cedar Keys. *Author's photo.*

A visitor in 1871 wrote his impressions of the Cedar Keys for *Harper's New Monthly Magazine.* His description began with compliments for the "prettily situated" village and the ability of the residents "to make it a tolerable abiding-place." But the writer did not care much for the way Cedar Key people were handling their lives. He began, "So here it is possible that a paradise almost can be realized." Almost? He continued, using italics for emphasis:

> *The accessories of nature are so profuse and grand, so full of use and beauty; but how stupid are the people, the indigenous race, called* crackers! *Pale, sharp-visaged, sandy-haired people, ignorant beyond all reason; little can be expected from them—or* nothing, *but to vegetate.*

Those were the busy days of railroad trains coming and going twice a day with passengers and freight, carrying the produce from the area's waters and woods to the rest of the world. Much of that ended in the early 1900s, when the lumber business virtually stopped and other coastal cities developed deep-water ports. In 1932, the Interstate Commerce Commission

granted permission to end service on the last rail line linking the islands to the mainland, from Archer to Cedar Key. The final train departed Cedar Keys with workers who removed the tracks behind the last car.

Defining Cedar Key today is possible only for those who spend enough time there to understand the apparent lack of urgency. A community acceptance has developed—of tolerance and quiet, of unchanging lifestyles, of doing without a McDonald's or Office Depot. And, it must be added, a respect for yesterday. The shortest route to a "today" is by going over State Road 24 to a Dollar General store eight miles away. That is the only highway in and out of Cedar Key. It was built with bridges and by filling in some intra-island gaps with stones, shells and dirt.

On his website, artist-author Roger Bansemer of Clearwater described the modern island:

> *Cedar Key now seems to be frozen in time. The nearest major town, Gainesville, is sixty miles away. You won't find a K-Mart, convenience stores, or fast-food restaurants anywhere nearby. A small, family-owned grocery store, a few nice galleries, and some good, locally owned seafood restaurants are what you'll discover here... Today Cedar Key remains one of Florida's hidden treasures, with its old Florida charm.*

Some of those treasures can be reached only by boat. The Waccasassa Bay Preserve State Park website reports that the bay is "rich with cultural history dating from [the] pre-Columbian" period.

> *Florida's early pioneers homesteaded and hunted deer, turkey and bear here. They cut timber and "cow hunted" as well. Yet their activities did not greatly alter the wilderness character of the land. The hammock played a major role in the development of Cedar Key, providing cedar for the pencil factories and palm trees for the fiber factory. Remnants of the boilers once used in the production of brushes and brooms made from the sable palm fibers can be found within the boundaries of the preserve. Another remnant of bygone industry is Salt Island, named for salt kettles found there which were used to extract salt from salt water during the Civil War. Numerous home sites of early settlers as well as Indian sites and artifacts have been found in the preserve. Disturbance of these sites and the removal of any artifacts is prohibited.*

There is much more to this way of living than a short-time visitor sees. Natives and retirees from far-off metropolises alike enjoy being where life in

the twenty-first century is, in many ways, conducted at a nineteenth-century pace. A *Cedar Keys Beacon* poll of readers in late 2008 asked, "What do you most like about living on Cedar Key?" The mailed responses were: nature, 46 percent; water, 27 percent; friendly people, 18 percent; artistic culture, 9 percent; and nightlife, 0 percent.

There have been many major storms in the Cedar Keys–Suwannee area over the years, the most recent of which was Hurricane Easy in 1950. Islanders know, as Jon Erickson points out in his book *Violent Storms*, that "hardly a day goes by that there is not a major storm which takes lives and destroys property in some part of the world."

The weekly newspaper carries a warning notice seen also on signs posted around the island. Despite the easy pace at Cedar Key, residents and visitors are not allowed to forget that the islands may one day become a new hurricane's target. Sponsored by the Cedar Key Fire Department and the Levy County Emergency Management office, the notice says: "Warning Sirens. If you hear a three-minute siren blast, then Levy County has issued a MANDATORY EVACUATION for Cedar Keys and surrounding low-lying areas. If a storm comes, the Water Dept. will turn off the water supply for safety! Be prepared!"

Perhaps one reason that today's residents are not worried about the next storm is because they know they will have more forewarning than those who lived there in 1896. But then, living on the Cedar Keys has never been overly stressful. A historical society project a few years ago led to an alphabetical listing of those whose remains are buried at the city cemetery. Sixteen of them were born in 1896. Surely they heard often of their arrival in relation to the hurricane. That didn't seem to bother them. Of the sixteen, twelve lived into their seventies. Five were older than eighty when they died.

The cedar forests are gone but island life goes on, sometimes even at night.

THE CASUALTIES

The final national count of deaths from the September 29–30, 1896, hurricane stands at 130, according to the National Hurricane Center.[56] The Cedar Keys suffered about one-fourth of the toll. The islands, as accurately as I can determine, had thirty-one deaths. Not all are verified in more than one news account, survivors' memoirs or island death records.

The newspapers did their best to record the fatalities. On October 6, the *Florida Daily Citizen* reported twenty-four deaths at Cedar Key: "Most of the bodies were buried where they were found."[57] On October 8, the *Jacksonville Times-Union*'s report on the islands noted:

> The death roll has not materially increased since the last report, and several of those thought to be lost have turned up. The names of those known to be drowned follow: George, Henry, and Frank Havens, Mrs. Beacham, Mrs. C.W. Doar and three children, Mrs. Missouri Branch and daughter, S.C. Gause, Sam G. Robinson, Frank Hall, and Slim Branning, all whites, and Bradshaw Campbell and four spongers, colored; also, Dr. J.C. Speer, Samuel Register, Alice Bass, Joe Brooker, and Leda Mozell.

The latter name was later referred to in several newspapers as "L. Ezell," and Branning's first name was given later as "Hall."

One account referred to the "Speer party" and indicated that Captain Register had taken the visiting Dr. Speer, Mr. Brooker, Ms. Bass and Ms. Mozell/Ezell on an overnight boat trip to the Suwannee River.

The following is an alphabetical list of those who died in the Cedar Keys:

Cedar Keys City Cemetery has some of the 1896 storm's victims, some residents say, but none of the grave sites is identified. *Author's photo.*

NAME	WHERE	SOURCE
Anonymous Sponger #1		Newspapers
Sponger #2		Newspapers
Sponger #3		Newspapers
Sponger #4		Newspapers
Alice Bass (in Speer party)	Bird Rookery	Newspapers
Emily Beacham*	Big Bradford	McElveen/Newspapers
(Mrs.) Rosa Branch	Buck Island	Yearty/Newspapers
Branch Child #1		
(daughter)	Buck Island	Yearty
Branch Child #2	Buck Island	Yearty
Branneu Boy #1	Deer Island	Yearty
Branneu Boy #2	Deer Island	Yearty
Branneu Boy #3	Deer Island	Yearty
Hall Branning		Newspapers
Captain Joe Brooker		
(in Speer party)		Newspapers
Bradshaw Campbell		Newspapers

THE CASUALTIES

NAME	WHERE	SOURCE
Elizabeth Doar	Buck Island	Holman/Yearty/ Newspapers
Doar Child #1	Buck Island	Holman/Yearty/ Newspapers
Doar Child #2	Buck Island	Holman/Yearty/ Newspapers
Doar Child #3	Buck Island	Yearty/Newspapers
Doar Niece	Buck Island	Delaino
Doar Niece Child #1	Buck Island	Delaino
Doar Niece Child #2	Buck Island	Delaino
L. Ezell/Leda Mozell (in Speer party)	Bird Rookery	Newspapers
Sam C. Gause	Long Cabbage Island	Delaino/Newspapers
Frank Hall	Little Bradford Island	Yearty
Frank Havens (son)	Axe Island	Delaino/Newspapers
George W. Havens	Axe Island	Delaino/Newspapers
Henry Havens	Axe Island	Delaino/Newspapers
Captain Sam Register	Bird Rookery	Delaino/Newspapers
Captain Samuel G. Robinson	Buck Island	Yearty/Delaino/ Newspapers
Dr. J.C. Speer (in Speer party)	Bird Rookery	Newspapers

*Delaino mentioned both "Mrs. Beecham" and "Mrs. Beauchamp." It seems certain that this was Emily Beacham, wife of James W. Beacham.

At least one genealogy lists Charles Doar as a victim, too, but Yearty's and Delaino's accounts seem accurate in placing him away from his family home on Buck Island. Delaino wrote: "Across Suwannee Bay on Long Cabbage, there were four men camping and fishing: George Wadley, Joe Andrews, Charles Doar, and Sam Gause. They lost all their fishing gear and Sam Gause was drowned." Yearty also listed Cabbage Island survivors as Doar, Andrews and Wadley.

Delaino reported that the Doar family had lived on Buck Island, "just inside of Long Cabbage." Like Sam Robinson, "a man who was on the island with them," all eight of them drowned. He added that on Cedar Key "there was no one hurt or lost except one colored man; he was washed away in one of the fish houses."

APPENDIX

In his family report in *Search for Yesterday*, Will Yearty listed thirteen drownings that he knew of:

three Branneu boys that lived on the south end of Deer Island, Frank Haven, who lived on Little Bradford island, and Sam Gause, who lived on Cabbage Island. Mrs. Charley Doar and three children who lived on Buck Island; Mrs. Rosa Branch and her two children, and Sam Robinson, who also lived on Buck Island. Six weeks later, we found Mrs. Branch and buried her on Robinson Island. Those saved on Buck Island were Captain George Robinson, Bud Young, and John Burnett.

There is no way of telling how many deaths came days and weeks, or even months, later because of storm injuries. And then there are the reports of deaths that showed up in odd places or at odd times. An example is found in the *Jacksonville Times-Union* for October 16, 1896, reporting six deaths. The page-two story was headlined "To Be Added To The Hurricane's Long Death-Toll; Mrs. Paul Hewitt, Her Uncle and Four Children Lost; Their Corpses Reported Found." The story began, "Nearly every day adds to the death list of the recent storm. The latest victims are Mrs. Paul Hewitt, her daughter, brother, and sister, and her uncle and his son." They had left the Hewitt home near Tampa, headed for Cedar Key in "a 25-foot sharpie that was considered, at best, unseaworthy." Mr. Hewitt eventually received a letter—not the one he had expected from his wife reporting a safe landing—"that confirmed his worst fears." The newspaper story said:

The sharpie had never arrived at Cedar Key and no intelligence had been received of the whereabouts of the party, except that pieces of wreckage had been found on the coast below Cedar Key that were supposed to be from the boat in which the party sailed. A report also [was] received [in Tampa] that six corpses had been found under a boat which had been blown on the beach and turned over, the inmates being caught and buried. It is supposed that these corpses are those of Mrs. Hewitt and party.

Some newspaper reports of fatalities and names of victims seem to have appeared in only those issues. For example, several newspapers dated October 1 had the following to say about Cedar Key deaths:

Of the twenty bodies recovered, twelve are white and eight are colored. Of the white, six belong to the Whitson family—a mother, four children, and a visitor...Of the eight colored, only one, Peter Woodson, has been identified.

The Florida State Museum at Cedar Keys displays, among many items, a *Tampa Tribune* report of the 1896 hurricane. *Author's photo.*

Most of the victims were buried deep in mud...and most of the bodies will probably never be recovered.

None of the Whitsons or Woodson is otherwise listed anywhere.

Verification of the death count among spongers has apparently never been made. The *Atlanta Constitution*, on October 2, 1896, carried a lengthy report that said as many as seven hundred men aboard sponging vessels had

perished. That story was repeated in other newspapers, and a reprint, from the *Tampa Tribune*, hangs on the wall of the Florida State Museum at Cedar Key. The Atlanta newspaper's report stated:

> *But deplorable as is the loss of life in Cedar Keys proper, it is as nothing in comparison with the number of spongers and fishermen who were drowned. The* Mary Eliza *sponging schooner reached Cedar Keys at 10 o'clock this morning jury rigged, having had to cut both masts away to prevent capsizing. She reports that at dark Monday night nearly one hundred vessels were anchored on the sponge bar, just below Cedar Keys, and that nearly every one of them was sunk by the hurricane. At daylight Tuesday morning, the Captain of the* Mary Eliza *says he saw only about twenty of the one hundred spongers and fishing vessels afloat, the others having gone to the bottom during the early hours of the storm. Twelve of the twenty vessels that rode out the hurricane during the hours of darkness, the* Mary Eliza's *captain says, went down about 8 o'clock Tuesday morning. Beyond the bar, the tops of scores of masts are visible just above the water, and each top indicates the burial place of a sponging schooner and its crew. As these vessels carried four to ten men, the loss of life is hardly less than 700. It is possible that many of the vessels were blown into the gulf and rode out the*

This memorial to spongers stands dockside at Tarpon Spring. *Author's photo.*

hurricane, but the Mary Eliza*'s captain thinks by far the greater number are beneath the water with their crews. He says that there was not one chance in a thousand for such frail craft to live in such a hurricane.*

The following day, October 3, the *Florida Daily Citizen* wrote that "the fate of many of the spongers off Cedar Key will never be known and they will be reported as 'missing and not accounted for.'"

The late October accounts, attempting to provide a comprehensive list of the dead in the Cedar Keys, settled on there being only three spongers, none of them named. One of the unconfirmed explanations given for why only three bodies had been counted from among the many spongers—whether the true total was only eight or as many as seven hundred—is that the others were washed up on the mainland several miles away. Another speculation is that people in the Waccasassa Bay and the Withlacoochee Bay areas, overburdened with the enormous problems of simply staying alive, would not have taken time to look for spongers who had come from Key West—"conches," as the black Bahamians were called. Some newspapers, however, reported that two unnamed men had gone down the coast south of Cedar Key and saw the bodies of eight men washed up on the shore. "The [dead] men were the crew of a sponging vessel," the story noted, "and the crews of most of the other vessels undoubtedly have met a similar fate."

Lindon Lindsey, Cedar Key native and historian, does not believe that many spongers were in fact killed by the storm. He told me:

> *These were men of the sea. They could read the weather signs and the Gulf water. I believe they recognized the signs of a huge storm coming and took their vessels around to the back side of the Cedar Keys and rode out the storm.*

F.H. Bigelow, in a "rather elegant description of a hurricane" in 1898, wrote:

> *The physical features of hurricanes are well understood. The approach of a hurricane is usually indicated by a long swell on the ocean, propagated to great distances and forewarning the observer by two or three days.*[58]

NOTES

Introduction

1. Professor Bigelow's report appears in Williams and Duedall, *Florida Hurricanes and Tropical Storms*, 8–9.
2. Sidney Gunnell wrote, "The term Key (pronounced as in door key) is an adaptation of the Spanish word for island, Cay."
3. The name "Swanee River" is spelled phonetically in Stephen Foster's 1851 composition, "Old Folks at Home."
4. Dunn and Miller, *Atlantic Hurricanes*, 60.
5 Gunnell wrote a weekly history column, "Search for Yesterday," in the *Chiefland Citizen*, and many of the columns have been reprinted in a series of booklets under that name by the Levy County Archives Committee. A list of one hundred vanished towns appears in Levy County Archives Committee (hereafter LCAC), *Search for Yesterday*, ch. 16, 14–15.
6. *Orlando & Central Florida Adventure Guide*, January 1, 2000.

Chapter 1

7. From a letter to the newspaper editor, signed at Atlanta, October 2, 1896, and printed on page one of the *Atlanta Constitution* on October 3, 1896.
8. All technical data about hurricanes are from federal weather services, including the National Hurricane Center, the National Oceanographic and Atmospheric Administration and the Weather Bureau. Some interpretive information has come from the website www.Stormpulse.com. Technical definitions that follow were prepared by Dr. Christopher Landsea, science and operations officer at the National Oceanographic and Atmospheric Administration, Miami. See www.aoml.noaa.gov/hrd/tcfaq/A1html and www.aoml.noaa.gov/hrd/tcfaq/A7.html. A summary follows:

The terms *hurricane* and *typhoon* are regionally specific names for a strong "tropical cyclone." A tropical cyclone is the generic term for a non-frontal, synoptic scale, low-pressure system over tropical or subtropical waters with organized convection (i.e. thunderstorm activity) and definite cyclonic surface wind circulation.

Tropical cyclones with maximum sustained surface winds of less than 17 m/s (34 kt, 39 mph) are called "tropical depressions." Once the tropical cyclone reaches winds of at least 17 m/s (34 kt, 39 mph) they are typically called a "tropical storm" and assigned a name. If winds reach 33 m/s (64 kt, 74 mph), then they are called:

- "hurricane" (the North Atlantic Ocean, the Northeast Pacific Ocean east of the dateline or the South Pacific Ocean east of 160°E)
- "typhoon" (the Northwest Pacific Ocean west of the dateline)
- "severe tropical cyclone" (the Southwest Pacific Ocean west of 160°E or Southeast Indian Ocean east of 90°E)
- "severe cyclonic storm" (the North Indian Ocean)
- "tropical cyclone" (the Southwest Indian Ocean)
- tropical depression: a tropical cyclone in which the maximum sustained wind speed (using the U.S. one-minute average standard) is 33 kt (38 mph, 17 m/s); depressions have a closed circulation.
- tropical storm: a tropical cyclone in which the maximum sustained surface wind speed (using the U.S. one-minute average standard) ranges from 34 kt (39 mph,17.5 m/s) to 63 kt (73 mph, 32.5 m/s); the convection in tropical storms is usually more concentrated near the center with outer rainfall organizing into distinct bands.
- hurricane: when winds in a tropical cyclone equal or exceed 64 kt (74 mph, 33 m/s) it is called a hurricane (in the Atlantic and eastern and central Pacific Oceans); hurricanes are further designated by categories on the Saffir-Simpson Scale. Hurricanes in categories 3, 4 and 5 are known as major hurricanes or intense hurricanes.

The wind speeds mentioned here are for those measured or estimated as the top speed sustained for one minute at ten meters above the surface. Peak gusts would be on the order of 10 to 25 percent higher.

9. All information attributed to Marbury appeared in the *Atlanta Constitution* on October 1, 1896.

10. Marbury wrote "A Technical Description of the Great Storm," which appeared with a map showing the hurricane's path on page one of the *Atlanta Constitution* on October 1, 1896. While it may have passed peer inspection in 1896, his understanding of hurricane weather was surpassed long ago.

11. Jay Barnes's *Florida's Hurricane History* quotes an article, "Hurricanes Haunt Our History," by Patrick Hughes in *Weatherwise*.

12. According to a metal memorial marker on Cedar Key, Muir "first expressed his belief that nature was valuable for its own sake, not only because it was useful for man." He was to carry out his dreams of conservation and wildlife protection, notably by forming the Sierra Club and helping establish Yosemite National Park in California. The memorial marker was sponsored by the Florida Chapter of the Sierra Club in cooperation with the Florida Department of State.

13. William P. Delaino's account of his life was made available to *Search for Yesterday* by his family. Before he died in 1958 at age seventy-six, he recounted his life's experiences for his daughter-in-law, Mary Ann Delaino.

14. The Yearty group's storm experience appears in William S. Yearty's article, "The Yearty Family," in LCAC, *Search for Yesterday*, ch. 11.

15. This account is taken from an interview reported in a newspaper story written by Freemon H. Hart (clipping undated).

16. Later, in married life, Katherine McCumber McElveen recalled her experiences in an interview with Lindon Lindsey. LCAC, *Search for Yesterday*, ch. 11.

17. Tawes told his story in his book, *Coasting Captain*, which compiled his journal entries and ships' logs.

18. Barnett, *Fifty Years Down the Suwannee River*, 191–203.

19. The name is also recorded as the Florida Transit and Peninsula and as the Atlantic, Gulf & West Indies Transit Company, according to George Bartlett in the October 15, 1945 *Floridian* (St. Petersburg).

20. Fishburne tells of John Muir's working at a sawmill operated by Robert W.B. Hodgson. When Muir became ill with malaria, Mrs. Hodgson nursed him through recovery. Muir wrote of enjoying the view from the home on the hill across the water to Lime Key. From the article "Hodgson Hill in Cedar Key," in LCAC, *Search for Yesterday*, ch. 11.

21. Turpentine was first used for shipbuilding and lighting and as a solvent for other materials, including printing ink, polishes, waves, paint and varnish.

22. George Bartlett, "The Story of Cedar Key," *Floridian*, October 20, 1945.

23. Information about Eagle and Faber history and operations is taken from Petroski, *The Pencil*.

24. The "slat" was a piece of wood that Petroski describes as six pencils wide, a little longer than a seven-inch pencil and the thickness of half a pencil. Into the slat a saw cut six grooves for the insertion of lead. With a second slat joined, the entire assembly was cut into six pencils, which were painted and embossed with the company name.

Chapter 2

25. LCAS, *Search for Yesterday*, ch. 16.
26. Reprinted in Oppel and Meisel, *Tales of Old Florida*, as "Turtling in Florida."
27. Throughout this book, the 1896–2009 conversion rate of 1:42 is based on "Consumer Price Index Conversion Factors" determined by Robert C. Sahr, Oregon State University. Other conversion charts may vary by a few points.
28. Delaino may have been paid in the new and ornate silver certificates designed by the Bureau of Engraving and Printing and issued on July 14, 1896, to public confusion.
29. From an 1892 magazine article by Kirk Munroe, reprinted in Oppel and Meisel, *Tales of Old Florida.*
30. *Tampa Tribune*, September 16, 1990, news story by Nicholas W. Pilugin; and Tarpon Springs Chamber of Commerce brochure.
31. LCAC, *Search for Yesterday*, ch. 11.
32. Newspapers later were to name four others who were with Captain Register, apparently visitors who had hired him and his boat for a trip on the Suwannee River.
33. James W. Beacham's story, "Letter to Mrs. Keifer," may be found in LCAC, *Search for Yesterday*, ch. 7.
34. The National Hurricane Center–National Oceanographic and Atmospheric Administration has records of Tropical Storm 4 on September 27, 1875, coming out of the Gulf of Mexico and making landfall northwest of Cedar Keys. It is more likely that Nick Wilder was remembering another storm, remarkably also called Number 4 and occurring on the same dates in 1874. Jay Barnes's *Florida's Hurricane History* notes that the storm "came from the Gulf and crossed the Florida coast near Hog Island, just north of Cedar Key."
35. Yearty, "The Yearty Family," in LCAC, *Search for Yesterday*, ch. 11.

Chapter 3

36. Other estimates of the wave's height have been recorded, but ten feet is most often used by respected authors and historians, including Jay Barnes.
37. The term *tidal wave* has been used incorrectly to describe the hurricane surge. That is a misnomer, according to the U.S. National Oceanographic

and Atmospheric Administration. "Tides are the result of gravitational influences of the moon, sun, and planets." Nor is calling a surge a tsunami accurate, since that condition is caused by an earthquake. Tsunami is a Japanese word that means "harbor wave." The term *tsunami* was adopted for general use in 1963 by an international scientific conference. NOAA adds: "Tsunamis are not caused by the tides and are unrelated to the tides; although a tsunami striking a coastal area is influenced by the tide level at the time of impact." http://wcatwc.arh.noaa.gov/physics.htm.

38. On October 11, 1896, the *Florida Daily Citizen*, published in Jacksonville, devoted an entire page to Cedar Key, detailing all business losses and displaying six photographs. Unless otherwise noted, all damage reports here are taken from page nine of that issue.

39. This area has since become settled and adopted the river's name, Suwannee.

40. Because a smaller nearby island is called Little Bradford, the larger island is known locally as Big Bradford.

41. This name is also spelled in various records as Doer and Door.

42. Wilma Holman of Cedar Key describes her family genealogy as follows: "Elizabeth Wadley, aka Lizzy, born about 1871, in Romeo, Macomb County, MI, to George Wadley and his wife, Sarah Harper Wadley. Lizzy was the fourth of eight children. She married Charlie Doar. There is some question about the spelling of the name. My mother gave me this information many years ago. Lizzy and three children, two of them boys we believe, were all killed on Buck Island."

Chapter 4

43. Sidney Lanier (1842–1881), had visited Cedar Keys but was not around for the 1896 hurricane, which his poem seems to describe. A celebrated poet, he followed a contemporary custom of writing in regional dialect.

44. A Florida Heritage Site memorial marker at the former Eagle factory location tells the story of Cedar Key lumber operations in the nineteenth and twentieth centuries. The large, metal marker was sponsored by the Florida Society of American Foresters and the Florida Department of State.

45. "Cake of talor" probably refers to tallow, a hard substance of animal fat that also was used in soap.

Chapter 5

46. In 1844, Captain Jonathan Walker, fleeing Pensacola with seven fugitives from slavery, made the Cedar Keys one of his nighttime stopping places in order to renew drinking water, as his boat and passengers aimed for the Bahamas and freedom under British law. His story is told in the book *Jonathan Walker: The Man with the Branded Hand,* by Alvin F. Oickle.
47. A large group of southern railroads were united under the name Plant System.

Chapter 6

48. The information in this chapter is not intended to represent total losses and damage caused by the Number 4 hurricane but rather to give examples of how widespread and vicious it continued to be on its path north from Florida.
49. The *City of Baltimore,* built in Bath, Maine, in 1884, had a gross weight of 356 tons and a net weight of 338 tons.
50. Information provided by Nancy Assmann of the Cayuga County historian's office.

Chapter 8

51. Dr. Putz co-wrote the research article "Predicting Sea-Level Rise Effects on a Nature Preserve on the Gulf Coast of Florida. A Landscape Perspective," published in the journal *Florida Scientist* in 2007. His coauthor was Hector Castaneda of the School of Natural Resources and Environment at the University of Florida.
52. Larisa R.G. DeSantis, Smriti Bhotika, Dr. Putz (University of Florida) and Kimberlyn Williams (California State University at San Bernardino), "Sea-level rise and drought interactions accelerate forest decline on the Gulf Coast of Florida, USA," *Global Change Biology* (2007).
53. Seahorse Key has a cemetery whose recorded deaths include two lighthouse keepers, four Union soldiers and a Confederate blockade runner and his son, according to the *Cedar Key Beacon,* January 15, 2009.
54. LCAC, *Search for Yesterday,* ch. 11, 14.
55. If these figures are correct, the storm would have traveled eleven hundred miles in twenty-four hours.

Appendix

56. An excellent source of information about all past hurricanes is the website maintained by the federal government at www.nhc.noaa.gov/index.shtml.
57. Such references were common for storm victims, but they were common in other circumstances as well. Katherine McCumber McElveen said: "I had a brother that died long years ago named Frankie. He's buried at Cedar Key with our parents; don't know where." Interview published in LCAC, *Search for Yesterday*, ch. 11.
58. Williams and Duedall, *Florida Hurricanes and Tropical Storms*, 8–9.

BIBLIOGRAPHY

There are many books, some scientific, some histories, about the Cedar Keys and hurricanes. The list below represents some of those I have read to gain background in the subjects. For history of the islands, I especially recommend the local history books by Kevin McCarthy and Charles C. Fishburne Jr. They are notable for their readability and for fascinating information on this strange place hanging rather casually into the Gulf of Mexico. Jay Barnes's account of the state's long history with hurricanes is easy to read while covering both scientific and journalistic types of information. For an hour or a year of fun reading, I recommend the *Search for Yesterday* series. You don't need a special interest in Levy County to enjoy the stories of life in old Florida. And to be transported into another world, take a look at the 1897 Sears, Roebuck & Co. catalogue.

Here are a few local history books that I found interesting and helpful:

Barnett, L.L. *Fifty Years Down the Suwannee River*. Branford: North Florida Printing Co., 1979.

Fishburne, Charles C., Jr. *Cedar Key Booming: 1877–1886*. Cedar Key, FL: Sea Hawk Publications, 1982.

———. *Sidney Lanier: Poet of the Marshes Visits Cedar Keys 1875*. Cedar Key, FL: Sea Hawk Publications, 1986.

A History of Cedar Key. Chiefland, FL: Cedar Key Beacon, 1996.

Levy County Archives Committee. *Search for Yesterday: A History of Levy County, Florida*. 28 vols. Bronson, FL: Levy County Board of Commissioners, 1977–2006.

McCarthy, Kevin M. *Cedar Key Florida: A History*. Charleston, SC: The History Press, 2007.

McIver, Stuart. *True Tales of the Everglades*. Miami: Florida Flair Books, 2004. Seventh printing.

Oppel, Frank, and Tony Meisel, eds. *Tales of Old Florida*. Secaucus, NJ: Castle/Book Sales, Inc., 1987.

BIBLIOGRAPHY

Tawes, Leonard S. *Coasting Captain.* Newport News, VA: Mariners Museum, 1967.

The following are books about hurricanes that I consulted:

Barnes, Jay. *Florida's Hurricane History.* Second edition. Chapel Hill: University of North Carolina Press, 2007.

Dunn, Gordon E., and Banner I. Miller. *Atlantic Hurricanes.* Revised edition. Baton Rouge: Louisiana State University Press, 1964.

Erikson, Jon. *Violent Storms.* Blue Ridge Summit, PA: Tab Books, Inc., 1988.

Williams, John M., and Iver W. Duedall. *Florida Hurricanes and Tropical Storms.* Revised edition. Gainesville: University Press of Florida, 1997.

For background on related subjects, I read:

Gonatos, John M. *The Story of the Sponge.* Tarpon Springs, FL: Greek-American Printing Co., 1946.

Jacobson, Morris K., and Rosemary K. Pang. *Wonders of Sponges.* New York: Dodd, Mead & Company, 1976.

Petroski, Henry. *The Pencil: A History of Design and Circumstance.* New York: Alfred A. Knopf, Inc., 1989.

Sears, Roebuck & Co. 1897 Catalogue. New York: Skyhorse Publishing, Inc., 2007.

Printed in the USA
CPSIA information can be obtained
at www.ICGtesting.com
LVHW020001120224
771557LV00002B/139